IMAGES
of America

MACKINAC ISLAND

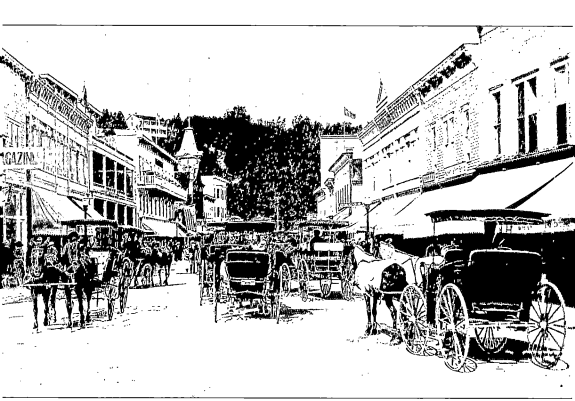

This postcard from the early 1900s shows Huron Street, known as the "Main Street" of the City of Mackinac Island, looking east. Horse-drawn carriages were the primary means of transportation due to a citywide ban on the use of private automobiles. This ban was enacted in 1898 by the city council and later duplicated to apply to the rest of the island by the Mackinac Island State Park Commission. The ban is still in effect today. (Courtesy of Bentley, Poole folder 12.)

ON THE COVER: Taken on September 1, 1909, this sweeping view from Fort Mackinac captures a group of people utilizing a cannon platform from which to view a ceremony taking place below. A park and new statue honoring Fr. Jacques Marquette, the 17th-century missionary and explorer, are being dedicated. From this vantage point, downtown City of Mackinac Island and the inner harbor can be seen extending to the southwest. (Courtesy of Mackinac State Historic Parks.)

IMAGES
of America

MACKINAC ISLAND

Tom North

ARCADIA
PUBLISHING

Published by Arcadia Publishing
Charleston, South Carolina

Printed in the United States of America

Library of Congress Control Number: 2009943861

For all general information, please contact Arcadia Publishing:
Telephone 843-853-2070
Fax 843-853-0044
E-mail sales@arcadiapublishing.com
For customer service and orders:
Toll-Free 1-888-313-2665

Visit us on the Internet at www.arcadiapublishing.com

To Walter and Sally North, my parents, who have
always been so unselfish in giving of themselves

CONTENTS

ACKNOWLEDGMENTS

As with most endeavors, a lot of things have to come together, and success depends upon the help of others. First, I am thankful to God for opening the door to this opportunity and enabling a solution to every issue that arose.

The Arcadia staff has been wonderful to work with, especially my editor, Anna Wilson, and my publisher, John Pearson. A thank-you goes to Eric Biedermann, a friend who, when employed by Arcadia, first suggested that I author a book for them. This book would have been much more difficult without the assistance of Mackinac State Historic Parks staff, especially Brian Jaeschke, and their publications and information. It would have been impossible without the images from Tom Pfeiffelmann, Madelyn Le Page, Armand "Smi" Horn, Paul Petosky ("Petosky") of Postmarks of the Past, Mackinac Island Library, Library of Congress, Metivier Inn, Margaret McIntire (proprietress of Hotel Iroquois on the Beach), Margaret Doud ("Doud") of the Windermere Hotel, Pat Andress, Mackinac Island Yacht Club, Rev. Tom Marx, Sally North, Bentley and Clements Libraries at the University of Michigan, Clarke Historical Library at Central Michigan University, and Archives of Michigan.

I particularly acknowledge the expert help of Brian Dunnigan, a Mackinac Island historian and author. Thanks for various forms of assistance go to the following: Star Line Mackinac Island Ferry and its general manager Mike North, Bob Benser Jr., and Brian Bailey (Chippewa Hotel), Mary McGuire Slevins (Mackinac Island Tourism Bureau), *St. Ignace News* and *Mackinac Island Town Crier*, Anne St. Onge, Ken Neyer, Tim McCleery, and Pat Rickley (Sault Tribe). Some of the historical information was provided by Bob Taggatz (Grand Hotel historian), Jeffrey Dupre (Island Photo–Mackinac Island), Jack Welcher, Sue Chambers, Larry Parel, the Murray family, Vic Callewaert (Island House), Mackinac Island State Harbor, and Inn at Bay Harbor.

Last, but not least, thanks to my friends for their support, and in particular to the Doug Drawbaugh family for hospitality during research trips to the Detroit area and to Beth Doyle for general inspiration to write a book.

The sources of most images are identified parenthetically in the captions. Sources that chose to remain anonymous are not identified. Diligent efforts have been made to verify that all necessary permissions for usage have been obtained prior to publication. Lengthier courtesy credits are keyed to the following references:

Bentley = Bentley Historical Library, University of Michigan
 Poole = Sarah Alicia Poole collection
 Greene = P.B. Greene collection
 McIntire = Sam McIntire collection
 Tanner = Andrew Tanner collection
 Visual Materials = Visual Materials Collection
 Postcard = Postcard collection
Clements = Clements Historical Library, University of Michigan
Clarke = Clarke Historical Library, Central Michigan University
 Trelfa = Fred and Tom Trelfa photograph collection
 Main = Main Photograph Collection
LOC = Library of Congress

INTRODUCTION

What is the first thought that comes to mind when reading or hearing the name Mackinac Island? Is it of horses rather than cars? The vintage charm of 19th-century hotels? Majestic 150-foot bluffs rising from the blue waters of Lake Huron? The possible mental images seem endless.

Perhaps the answer depends on whether you have ever lived on or visited "The Island," or whether it is a place you have only heard of. The thoughts and feelings conjured up are likely to be unique to each individual. That is because there is so much to this very special part of God's creation and to America's history. The combination of natural beauty, human history, spirituality, and Victorian-era romance of Mackinac are unrivaled anywhere else.

One of the two small towns from which ferryboats transport passengers and freight to the island is St. Ignace in Michigan's Upper Peninsula. Dating back to 1671, St. Ignace is one of the oldest continuously settled cities in the United States. The other, Mackinaw City, is located at the northern tip of Michigan's Lower Peninsula (the mitten-shaped part). The Straits of Mackinac, which joins Lake Michigan and Lake Huron, separates the two towns and peninsulas. The Straits has been spanned for over 50 years by the five-mile-long Mackinac Bridge.

No matter how it is spelled, Mackinac is pronounced "Mackinaw." The word derives from Mishinimakinang (place of the Great Turtle), which Native Americans first called the island. The name Michilimackinac was later phonetically applied to the whole region by the French. By the 1820s, the shorter versions, Mackinac and Mackinaw, were widely in use. (Fort Michilimackinac, built by the French, retained the old spelling; it is still maintained as a historic park in Mackinaw City.)

In chapter one, several images have been selected to orient the reader briefly and generally to the geography and geology of the island, given their importance to the area's rich history and culture. Chapter two reflects the author's belief that any history of Mackinac Island is incomplete without a respectful representation of "the First Visitors." For several hundred years before French missionaries and explorers came in the mid-1600s, Native Americans frequently travelled to the island, seeing it as a sacred place from which to fish. The Native Americans used high geological areas of the island to lookout for ships, boats, and canoes. During the Revolutionary War, because of its strategic military value, Mackinac Island was very important to America and Britain. This was even truer in the War of 1812. Chapter three illustrates Fort Mackinac (built in 1780 to overlook and control the Straits and passage between the Great Lakes), the smaller Fort Holmes, and other aspects of military presence. Fort Mackinac is now restored and part of the state park system.

As the country progressed toward peace, Mackinac Island shifted away from military prominence and toward more commercial interests. There were substantial increases in industries like the fur trade, fishing, and harborage for ships transporting passengers and goods. Later in the 19th century, tourism and recreation emerged. The City of Mackinac Island was incorporated around the harbor, and four churches were built as well as a school and other public buildings. Large resort hotels were developed. In 1875, Mackinac Island became the second national park in the nation, three years after Yellowstone. Ownership of the parkland and Fort Mackinac was transferred 20 years later to the State of Michigan, and the island became its first state park. Victorian mansions were constructed, many on land leased from the state. Chapters four, five, and six, respectively, cover churches and public buildings, the town and people, and the hotels and "cottages" (actually the majestic mansions of summer residents) of Mackinac.

The importance of ships and boats to an island is obvious, but for an average of three to four months, in the dead of winter, ice up to several feet thick surrounds Mackinac Island. Winter in the region is often severe, with most years forming an ice bridge permitting transit by snowmobile or other means to and from St. Ignace (albeit not always safely). When an automobile arrived for use on the island in 1898, a decision was made to ban them in the city so as to not panic horses on the narrow streets or impede the developing carriage-tour industry. The ban on private cars has continued, which is doubtless Mackinac's most unique feature. Only emergency vehicles, essential construction and maintenance trucks, and snowmobiles have been permitted on public roads. A small airport is the only link to the mainland during the seasons between open water and a firm ice bridge. Land travel is accomplished by foot, bicycle, or horse (with or without carriages or sleighs). Chapter seven considers the methods and challenges of getting to, from, and around an island without private motorcars and includes images of modes of transportation not seen in many years.

Tourism and recreation dominate modern Mackinac Island commerce, the subject of the final chapter. People have been coming to this magical island to relax and escape the "real world" for many years. The author hopes to convey the rarity of a place where people can visit and experience life as it was in an earlier era. A trip to Mackinac Island is in many ways a trip back in time and history. In 1931, on a monument still standing below Fort Mackinac, the Daughters of the American Revolution proclaimed, "Mackinac is the most historic place in Michigan." Mackinac Island has been a National Historic Landmark since 1960.

Although the chapters are organized around subject areas, a rough time line of Mackinac Island history is chronicled (with some necessary overlap). In each chapter, images and depictions of each historical place have generally been grouped together as well as immediately before or after images of similar subjects. These untitled "subchapters" give the reader an opportunity to compare the view of a particular place at different times and to spot some of the historical changes and developments.

For additional historical information about Mackinac Island, the contact information for Michigan's Mackinac State Historic Parks is 207 West Sinclair Street, Mackinaw City, MI, 49701. The telephone number is 231-436-4100, and the website is www.mackinacparks.com.

One

THE ISLAND

Mackinac Island
(then spelled
Mackinaw) is
centered in this
1837 area map of the
Straits of Mackinac,
which connects
two of the Great
Lakes, Michigan
and Huron, and is
detailed in the inset
map. Mackinac
Island is part of
Michigan's Upper
Peninsula, the
mainland of which
lies about four miles
to the west. To
the south, about
seven miles away, is
Michigan's Lower
Peninsula. (Courtesy
of Clements.)

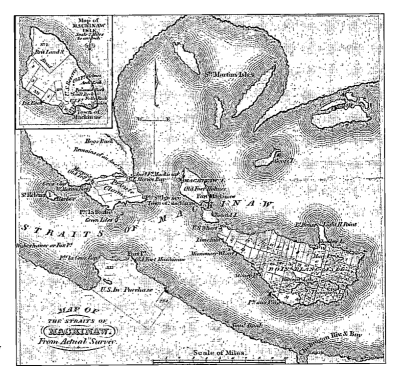

9

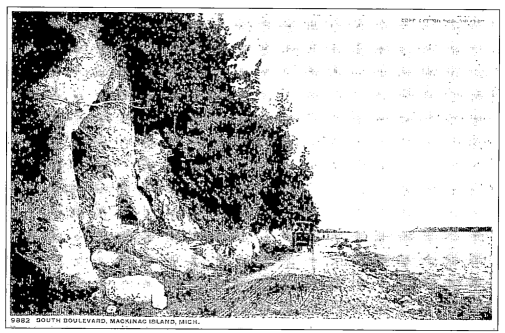

9882 SOUTH BOULEVARD, MACKINAC ISLAND, MICH.

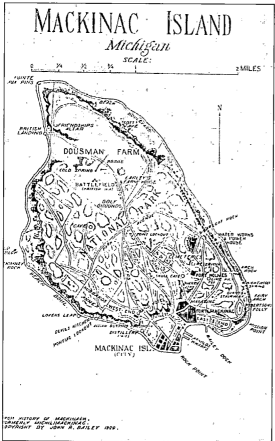

A horse and buggy are shown on South Boulevard along Mackinac Island's southwest shore. This photograph illustrates the elevations, which eventually reach 300 feet, rising above Lake Huron. The road was later paved and became Michigan Highway M-185 (Lakeshore Boulevard). It remains the only Michigan highway upon which private motor vehicles are not permitted. (Courtesy of Petosky.)

This 1909 guide map of Mackinac Island orients the user to the locations of island features. Although the map reads "National Park," in 1895 it was turned over to Michigan as its first state park. The park contains about 1,800 acres and encompasses over 80 percent of the island. In total, the island is over eight miles in circumference. (Courtesy of Madelyn Le Page.)

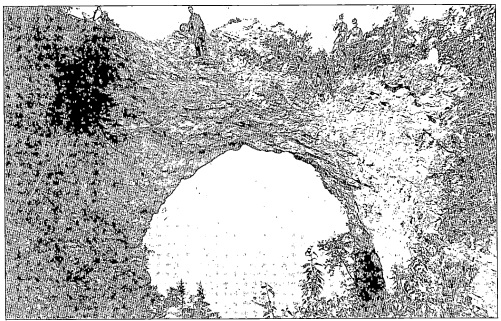

Mackinac Island has numerous unique and beautiful geological formations that have contributed to its human history. The most famous and frequently visited is Arch Rock (above), which sits above the southeast shore. It was a popular place to pose for photographs, as shown here in this image from about 1890. Mackinac Island is a limestone and shale mass that was carved by Ice Age glaciers. Note the boat framed by the arch. Below, members of a National Guard unit from Alpena, Michigan, on the island for maneuvers, took time out to similarly pose in 1887. Visitors are no longer allowed to climb on top of the arch, but there is a viewing platform near the top. It is accessed from a road behind the arch or by steps from Lakeshore Boulevard. (Above, courtesy of Bentley, Greene; below, courtesy of Clarke, Trelfa.)

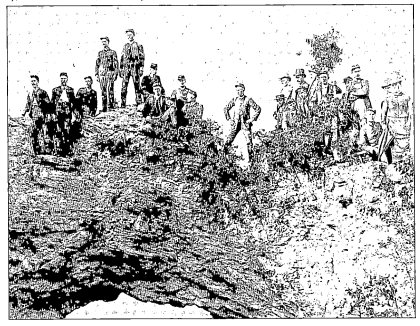

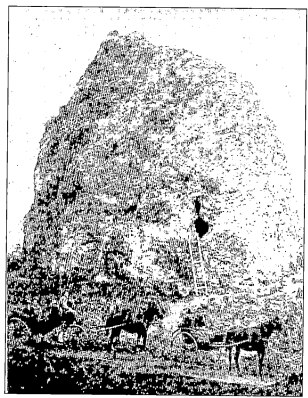

Another of Mackinac Island's famous geological formations is Sugar Loaf Rock, located in the island's interior. Sugar Loaf was also the site of frequent photograph opportunities for those adventurous enough to climb the 75 feet to the very top. Many old images show a ladder that was apparently left in place for climbers. Below, members of the 1887 Alpena unit of the Michigan National Guard strike an impressive pose on and around Sugar Loaf during time away from training on the island. Individuals in the photograph, including women, are not identified. Additional geological formations of Mackinac Island include the ominously named Skull Cave and Devil's Kitchen. (Left, courtesy of Armand "Smi" Horn; below, courtesy of Clarke, Trelfa.)

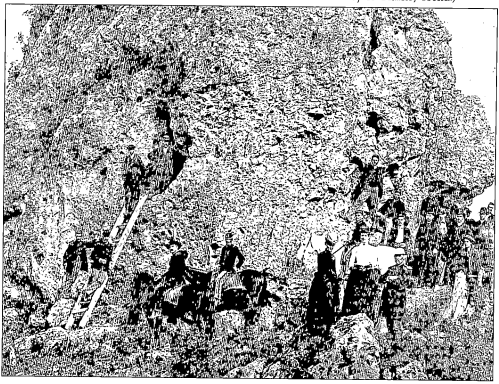

Just south of Mackinac Island is the much smaller and uninhabited Round Island, part of Hiawatha National Forest since the 1930s. The only structure on this island is the beloved and picturesque 1895 Round Island Lighthouse, which is no longer in use but has been restored for preservation in recent years. The lighthouse marked the Round Island Passage between the two islands. (Courtesy of Madelyn Le Page.)

While the Round Island Lighthouse was inhabited by a lighthouse keeper until 1948, its successor is an automated and unmanned beacon standing in the Round Island Passage. This lighthouse includes a foghorn that can be heard for miles. Shown is a Coast Guard photograph from 1949, the year that the new lighthouse began operation. Ships over 1,000 feet have frequently utilized this passage with the aid of the lighthouse and foghorn. (Courtesy of LOC.)

The steep bluff shown to the left in this postcard is called Robinson's Folly and is located above the southeast point of the island, known as Mission Point. Robinson was an officer at Fort Mackinac who constructed a home on this bluff. There are differing legends as to what the "folly" might have been. (Courtesy of Clarke, Trelfa.)

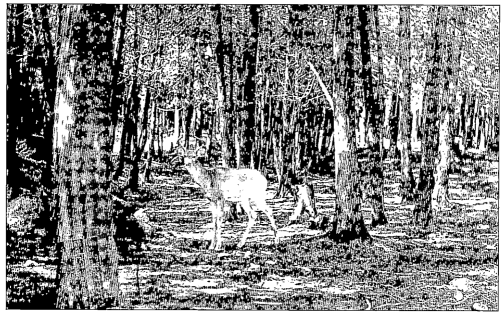

While this book is about the human history of Mackinac Island, about three-quarters of the island remains in its natural state, covered with forests and fields. However, there have been no large wild animals or hunting on the island in recent years. This photograph shows a deer park that existed off Garrison Road in the late 1930s. It was discontinued a few years later by the Mackinac Island State Park Commission. (Courtesy of Tom Pfeiffelmann collection.)

Two

THE FIRST VISITORS

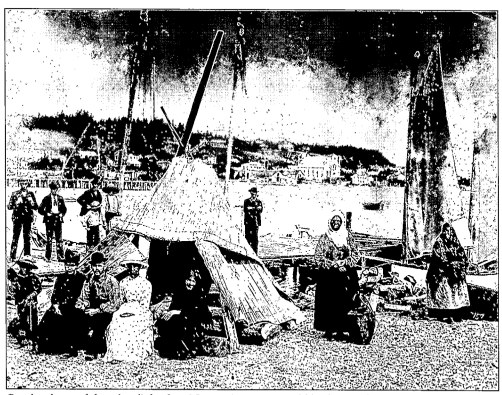

On the shore of the island's harbor, Native Americans sold baskets, fish, and woven mats to ship passengers. This photograph, dated about 1874, shows the newly completed St. Anne's Catholic Church in the background. Legend tells that mainland Indians saw an island in the shape of a sacred Great Turtle rise from receding Great Floodwaters. Science tells us that Lake Huron levels did drop 200 feet, but that this happened gradually. (Courtesy of Bentley, Poole folder 10.)

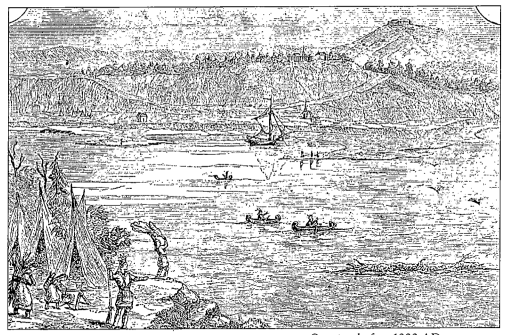

Starting before 1000 AD, seminomadic Woodland-period Indians visited Mackinac Island in the summer to camp, fish, and grow corn. The arrival of French explorers seeking a route to China began with Jean Nicolet in 1634. This sketch, copied from a woodcut engraving made after the construction of Fort Mackinac, is believed to depict the island and to represent its pre-photographic history. Efforts in 1875 to identify the engraving's source were unsuccessful. (Courtesy of Clements.)

This image shows the original deed to Mackinac Island, negotiated with four Ojibway chiefs and authored by Lt. Gov. Patrick Sinclair of the British 1/84th Regiment of Foot. In the name of His Majesty, 5,000 pounds worth of goods were exchanged and the deed signed on May 12, 1781. The original deed is owned by the University of Michigan; a second is believed to be at Library and Archives Canada. (Courtesy of Clements.)

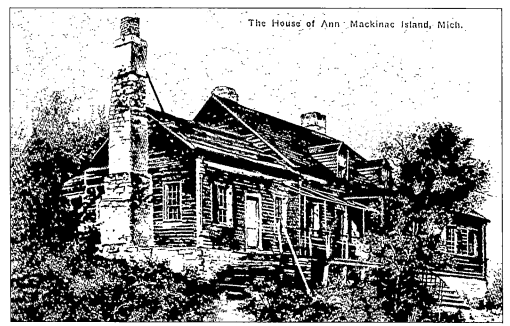

The House of Ann Mackinac Island, Mich.

After the War of 1812, the House of Ann was the Indian agent's home. His job was to administer treaties and agreed stipends and to address problems regarding Native Americans on the island. Native Americans had fought with the British and originally resented the return of the Americans in 1815. The most notable Indian agent was Henry Schoolcraft, who served from 1833 to 1841. The House of Ann burned in 1873. (Courtesy of Armand "Smi" Horn.)

The Mission House, built in 1825 and operated by Rev. Thomas William Ferry, served as a boarding school for hundreds of Native American children. In 1840, it was converted by E.A. Franks to a hotel for up to 200 guests. It was later acquired by Rev. Rex Humbard and then by the Mackinac Island State Park Commission in the 1900s. It is now closed to the public for continuing restoration. (Courtesy of Tom Pfeiffelmann collection.)

This Indian Dormitory was designed and built in 1838 by Henry Schoolcraft for the use of visiting Native Americans while conducting business with him or island fur companies. However, Indians rarely stayed in the dormitory. Located just east of Marquette Park in 1867, it later became the island's school. In 1967, the building became a Mackinac Island State Park museum. (Courtesy of Tom Pfeiffelmann collection.)

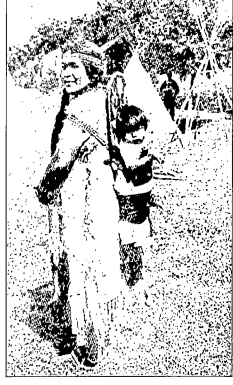

This undated image depicts a Native American mother and child in their camp on the Island. The Indians called Mackinac the "home of the fish," but the large game animals they depended on for survival were only present on the mainland. Once Fort Mackinac was built, a permanent island settlement that included Native Americans was established and sustained. (Courtesy of Tom Pfeiffelmann collection.)

This 1905 image portrays Native American basket, snowshoe, and handicraft makers with their beautifully crafted wares for sale below Fort Mackinac by the post gardens. The region's Woodland Indians divided into three tribes, with the Ojibwa tribe settling in the eastern Upper Peninsula, including Mackinac Island. The Ojibwa tribe is now known as the Chippewa tribes of northern Michigan. (Courtesy of LOC, number 4a17537u.)

A group of Mackinac Island Native Americans poses in this photograph, which is most likely from the first half of the 20th century. By the late 19th century, the island's Indian population primarily wore the same clothing styles as the non-Indian settlers. Traditional native costumes were, however, donned for cultural celebrations and events. (Courtesy of Archives of Michigan and Department of Conservation.)

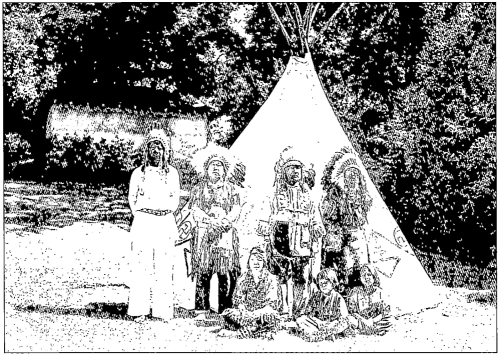

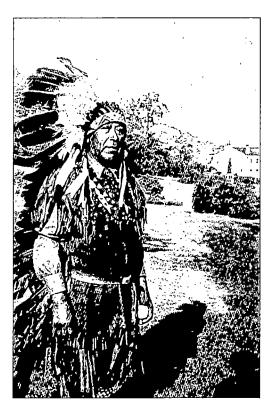

Taken in the 1940s, a photograph of a Native American man in traditional clothing highlights the proud culture of Mackinac's tribal people. The Indian Dormitory can be seen in the background. The 19th-century Indians preferred their camps on the beach to the dormitory, and as many as 3,000 at a time camped on the shore. Archaeologists have unearthed bone fishhooks, pottery, and spearheads from as early as 100 BC.

This 1940s picture shows a group of Indians in traditional costume posed in front of a wigwam on Mackinac Island. The wigwams shown in this and the previous image were for display only, although birchbark wigwams were used for lodging until the mid-19th century. Today, over 30 percent of the island's year-round population is of Indian descent.

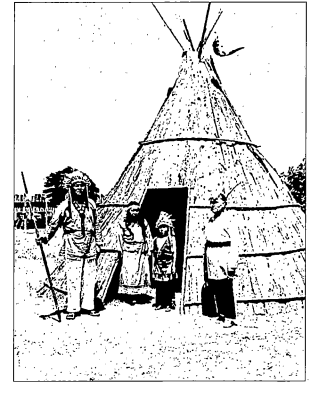

Three

OF SOLDIERS AND FORTS

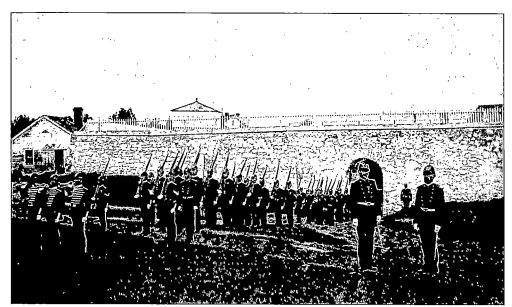

In the 1870s, the 22nd Regiment of the US Army performed training drills on the grounds immediately behind Fort Mackinac. The fort remained in use until 1895, when it became part of Mackinac Island State Park. It is now manned by park employees in costumes from the 19th century and can be toured during the park's summer season.

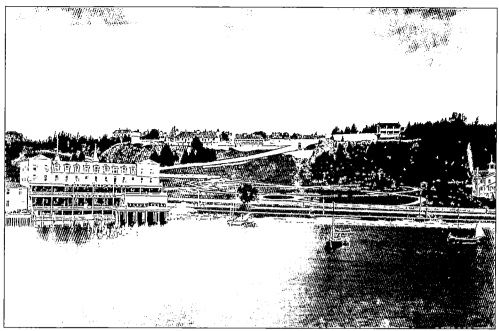

The British took Mackinac Island from France in 1761, following the Seven Years' War. Fort Mackinac was built beginning in 1780 after British Lt. Gov. Patrick Sinclair deemed Fort Michilimackinac not defensible in Mackinaw City, a conclusion reached following the 1763 massacre by Indians and the outbreak of the American Revolution. Fort Mackinac is shown shortly after 1900 from Haldimand Bay, Mackinac Island's harbor, which is named for Gen. Frederick Haldimand, the British governor of Canada.

Fort Mackinac's thick limestone walls, built to withstand cannon fire from ships, are seen in this 1906 tourist photograph. The British, and later the Americans, believed that the bluff overlooking the island's harbor was defensible because of its view and location. After finishing Fort Mackinac, the British abandoned and burned Mackinaw City's Fort Michilimackinac in 1781. Fort Michilimackinac has been reconstructed as part of the park system. (Courtesy of Mackinac Island Library.)

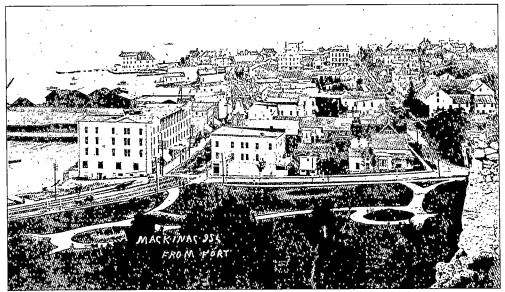

Fort Mackinac's elevation, 130 feet above the south end of the island and the Straits of Mackinac, is demonstrated by this 1890s view looking west. The fort commanded passage when all long distance travel in the region was by water, funneling through the Straits. The island and fort became part of US territory after the Revolutionary War, but possession was not taken until 1796. (Courtesy of Madelyn Le Page.)

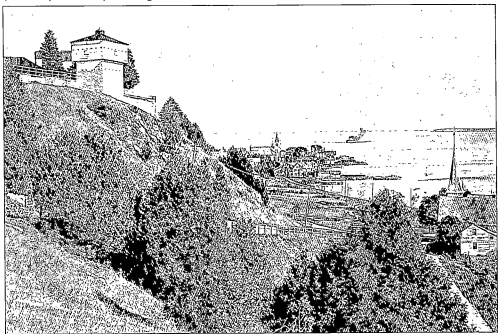

The view east to the Round Island Passage from Fort Mackinac was also strategic, as evidenced by this c. 1915 photograph taken from the slope slightly below the fort. Most ships traveling to and from the St. Mary's River, which leads to the Soo Locks and Lake Superior, travel through this passage. Smaller vessels can navigate in that direction to the north or south of Mackinac, Round, and Bois Blanc Islands.

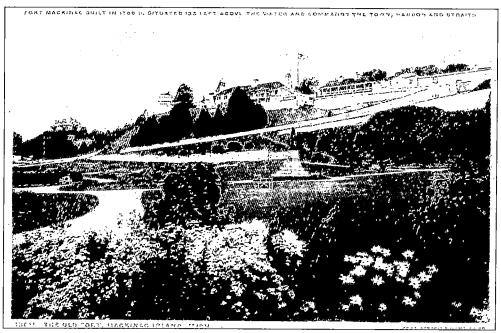

From 1875 to 1895, when Mackinac Island was a national park, the commander of Fort Mackinac served as park superintendent, and the fort's soldiers served as caretakers. By 1910, Marquette Park had been dedicated and the area looked peaceful. Mackinac Island has numerous State of Michigan historical markers explaining the significance of various registered historical sites. (Courtesy of Petosky.)

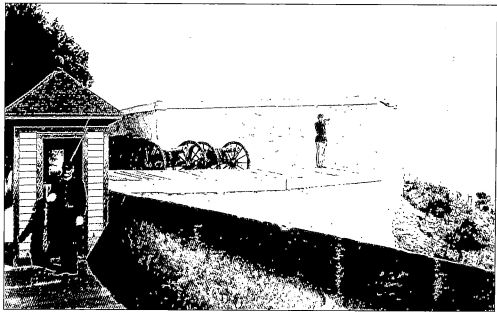

During the Civil War, a few Confederate prisoners were held at the fort under guard, while most of the soldiers were sent to the front lines. Taken when Fort Mackinac was still militarily active, this photograph shows a guard on duty and a bugler. Reveille and taps were played daily and are now played by park personnel in the summers. (Courtesy of Bentley, Poole folder 6.)

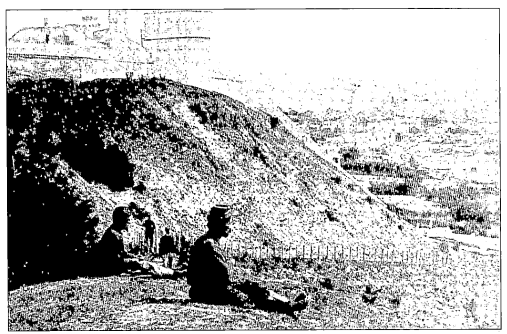

Company F, 1st Infantry soldiers are shown taking a break from duty. Fort life was often monotonous, although the view was unrivaled among military installations. Toward the end of its military service, an assignment to Fort Mackinac was considered desirable in comparison to other locations. It was once boasted that soldiers there bathed "once a week or more" after the bathhouse was completed in 1885. (Courtesy of Tom Pfeiffelmann collection.)

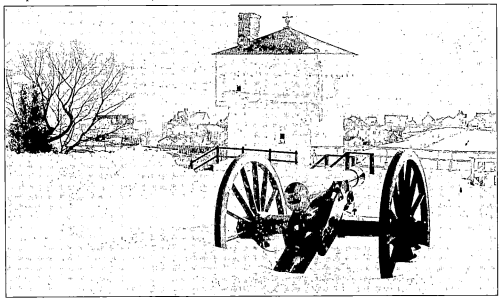

Winter was usually harsh at Fort Mackinac. Until 1879, the blockhouse shown also served as a schoolhouse for the children of soldiers stationed at the fort. Fort Mackinac had three such blockhouses, built in 1798 in a triangular pattern, and all containing cannons. Classes for the children, and for soldiers themselves, were moved to a post schoolhouse built within the fort in 1879. (Courtesy of Madelyn Le Page.)

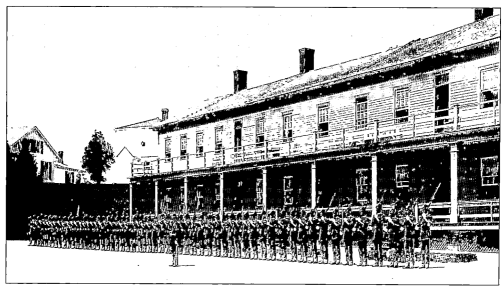

An 1886 dress parade of soldiers then stationed in Fort Mackinac is captured in this photograph that practically puts readers in the review stand. The fort's parade ground was used for drills, roll call, and inspections. In 1934, a Boy Scout barrack was constructed behind Fort Mackinac by the Civilian Conservation Corps.

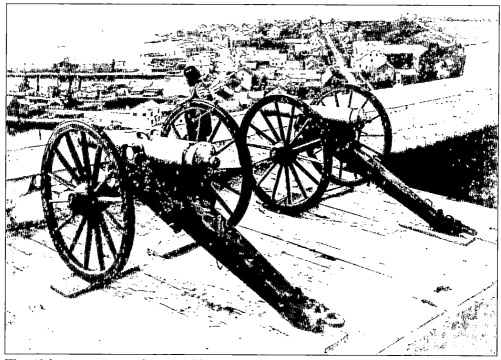

This 19th-century image shows a soldier manning two of the fort's cannons. A British officer wrote that the fort's influence extended throughout America and that large tracts looked to it for protection. During the summer months, Mackinac State Historic Parks personnel fire replica cannon from Fort Mackinac—without using cannonballs, of course. Two original cannons remain for viewing. (Courtesy of Tom Pfeiffelmann collection.)

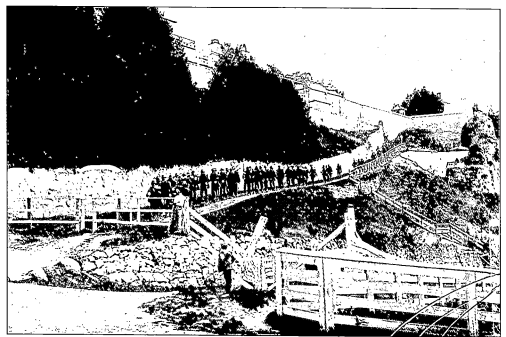

This October 9, 1894, photograph captured the scene as most of the soldiers stationed at Fort Mackinac marched out. For a year, the fort was left to the attention of a squad of caretakers. In 1895, it became part of Mackinac Island State Park. The ramp the soldiers are shown marching down is in front of the fort and still an access point for visitors. (Courtesy of Tom Pfeiffelmann collection.)

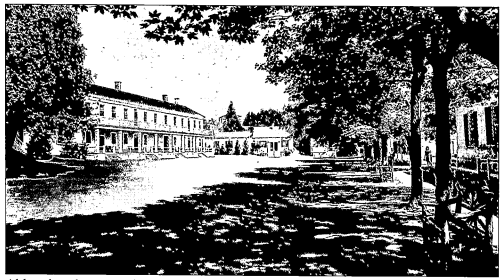

Although no longer a military outpost when this image was taken, the parade grounds and some of the buildings within Fort Mackinac are depicted in this 1942 image. The fort, with its original restored buildings, provides a highly educational experience for visitors. Its 14 buildings contain exhibits of weapons as well as personal effects and soldiers' quarters. The daily lives of the fort's soldiers and their families are shown through displays and period furnishings. (Courtesy of Tom Pfeiffelmann collection.)

The armaments of Fort Mackinac were significant and not limited to cannons. Shown is a Civil War–era 10-inch siege mortar with ammunition. The range of the fort's armaments increased as improvements were made over the years; eventually, this mortar and some cannons could reach ships almost two miles offshore. In fact, round shot was developed that could travel longer distances by skipping off the lake surface. (Courtesy of Tom Pfeiffelmann collection.)

Depicted is Fort Mackinac's artillery—including its one-inch Gatling gun from 1880—lined up for removal during a World War II scrap-metal drive. The Gatling gun was tested on Lake St. Clair, and with a range of over a mile, it could destroy an unarmored ship. A 24-pound cannon from Commodore Perry's Lake Erie Fleet remains near the island's marina as a monument. (Courtesy of Tom Pfeiffelmann collection.)

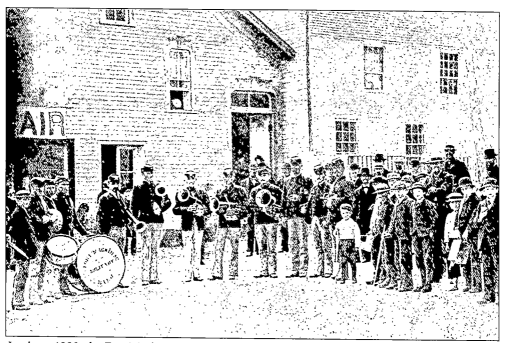

In about 1880, the Fort Mackinac Military Band posed in the village with its buglers, drummers, and fifers. Beginning in the mid-1800s, Fort Mackinac became a reserve post, with soldiers shipped out to serve in the Civil War and other conflicts. For those fortunate enough to remain or return, life included post dances in the barracks' canteen, billiards, and baseball and rifle teams that competed in the Straits area.

Mackinac Island received visits from US Navy ships traveling through the Great Lakes, particularly the paddlewheel frigate USS *Michigan*, whose crew occasionally stayed at Fort Mackinac. This marching band was made up of Navy sailors. Townspeople ran and walked alongside as the band made its way downhill from Fort Mackinac. (Courtesy of Clarke, Main.)

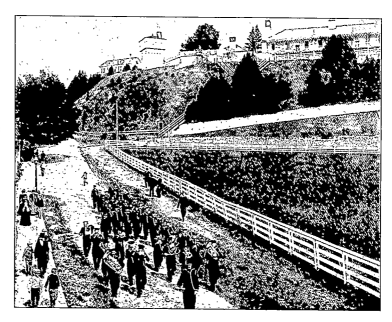

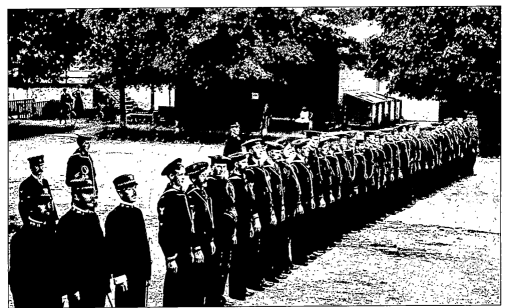

This early-20th-century image shows sailors, probably from the *Michigan*, in formation on Mackinac Island. The *Michigan* was the Navy's first iron-hulled steam warship and the only major warship of the American fleet on the Great Lakes from 1844 to 1923. Renamed *Wolverine* in 1913, it was one of the longest-serving ships in Navy history. (Courtesy of Clarke, Main.)

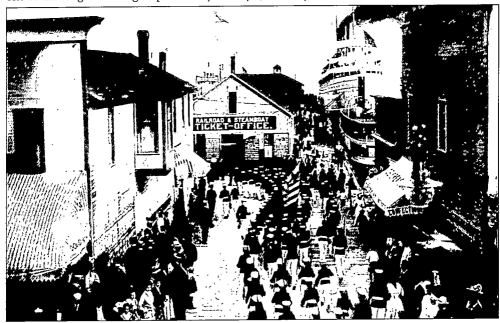

These sailors on Union Terminal Pier may have been returning to the *Michigan*. From 1850 to 1856, there were hostilities between Beaver Island in northern Lake Michigan and Mackinac Island; shots were fired and casualties inflicted over economic issues relating to commercial fishing and liquor laws. Both the *Michigan* and a colorful character named James Jesse Strang, the self-proclaimed king of Beaver Island's Mormon community, played prominent roles in the conflict. (Courtesy of Tom Pfeiffelmann collection.)

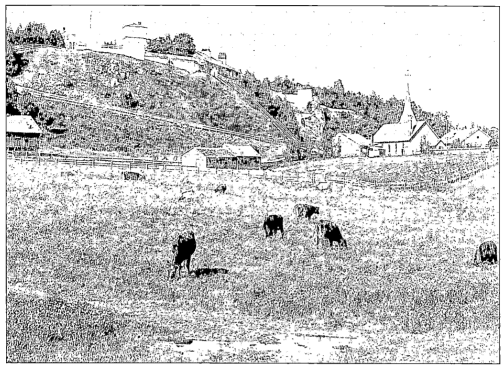

Today's visitors to Mackinac Island will not see any cows, but they were a common sight in the pastures of the 19th century. The open area below Fort Mackinac, which would become Marquette Park in the early 20th century, was formerly a garden and pasture that provided food to the soldiers and families in the fort. This reduced the need to transport a continual food supply to the island, which was especially difficult in bad weather. At the time that these images were taken, another pasture extended west from the current park area to behind Trinity Church and Market Street. The Park Commission charged $5 per year for residents to pasture a cow there. (Courtesy of LOC, numbers 4a03669u and 4a18489u.)

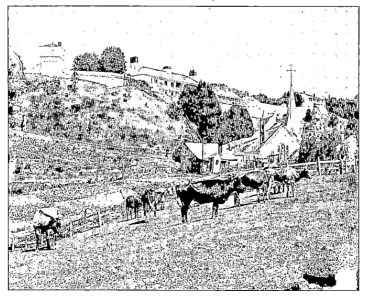

A 1962 image depicts the Beaumont Memorial, named after Dr. William Beaumont, the Fort Mackinac doctor. Here, from 1822 to 1825, he observed the stomach of voyageur Alexis St. Martin through an accidental gunshot wound that never fully closed. Dr. Beaumont's study of the human digestive system was a worldwide medical breakthrough. This American Fur Company Store, built in 1819, became a state park memorial in 1942. (Courtesy of Clarke, Trelfa.)

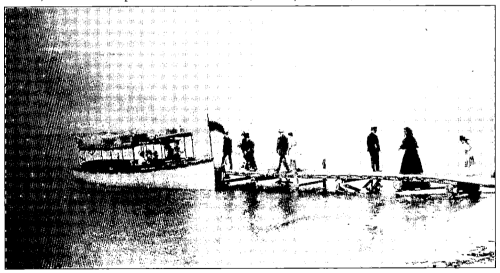

On July 16 and 17, 1812, over 600 British soldiers and Indian warriors landed at this place near the northwest shore. They advanced through the island and placed artillery both behind and above Fort Mackinac. They then demanded and obtained the surrender of a surprised Lt. Porter Hanks and about 60 US soldiers who did not know that war had been declared. The appropriately named British Landing has since been used for civilian boats.

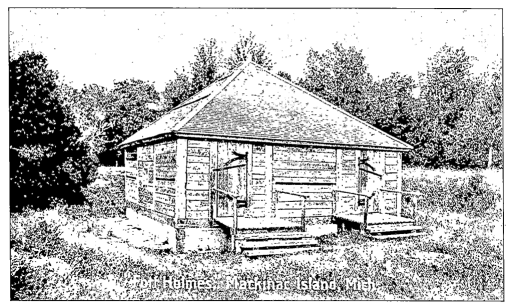
Mackinac Island's other fort, Fort Holmes, was small and is far less well known than Fort Mackinac. This is above the location from which British soldiers, led by Capt. Charles Roberts, forced the surrender of Fort Mackinac in the War of 1812. Originally named Fort George, it was built by the British on the island's highest point, 320 feet above Lake Huron, overlooking Fort Mackinac from the rear. (Courtesy of Tom Pfeiffelmann collection.)

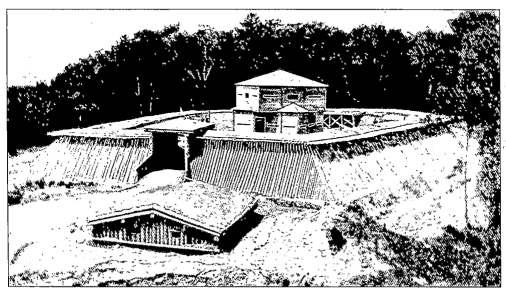
Constructed in 1814, Fort George was built as a deterrent to further attacks. It was later renamed for US major Andrew Holmes, who was killed in the battle of 1814. After a 1907 reconstruction burned in 1933, Fort Holmes was again reconstructed in 1936, this time by the Civilian Conservation Corps, based on historical research for design accuracy. (Courtesy of Bentley, Poole folder 18.)

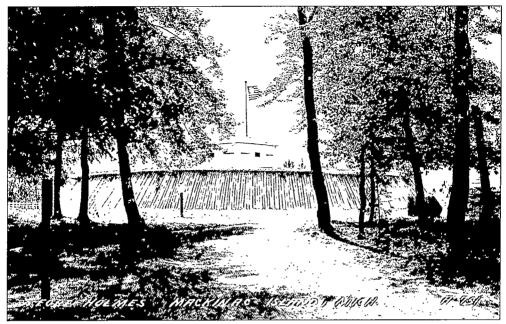

Another view of the reconstructed Fort Holmes reveals how it appeared from the only direction it could be accessed without climbing a steep bluff. The reconstructed Fort Holmes deteriorated and was burned by design in the 1960s. The fort has not been rebuilt again, and all that remains for visitors to see are earthworks and a gateway. (Courtesy of Madelyn Le Page.)

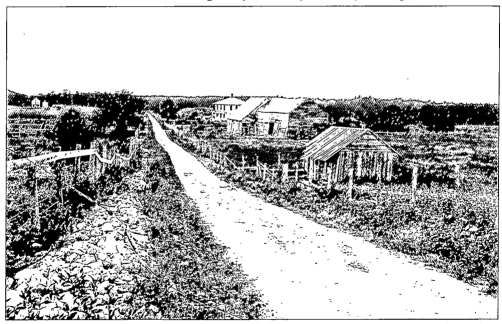

In 1814, after a naval bombardment failed, 750 Americans advanced overland from British Landing toward Fort Mackinac. They were defeated by 600 British and Indians and suffered 64 casualties, the island's only serious military battle. Blockades also proved unsuccessful, but 1815's Treaty of Ghent awarded America the island. The battlefield became the Early and Dousman family farms, which are depicted in this 1800s photograph. (Courtesy of LOC, number 4a3682u.)

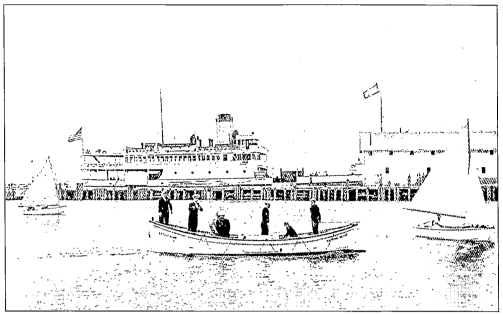

These sailors, shown in their boat in the early 1900s, are from either the Revenue Cutter Service or the Life-Saving Service (predecessors to the Coast Guard). Military watercraft from Haldimand Bay had shifted from controlling passage through the Straits 100 years earlier to making it safer. The dock in the background is Union Terminal Pier, the main pier on Mackinac Island for mooring larger ships and unloading freight. (Courtesy of Mackinac Island Library.)

In 1915, a Coast Guard station was built along the shore of the inner harbor, next to the Chippewa Hotel. When the Coast Guard moved to a larger station in St. Ignace in about 1969, the building was turned over to the Mackinac Island State Park Commission and became a visitors center. (Courtesy of Rev. Tom Marx.)

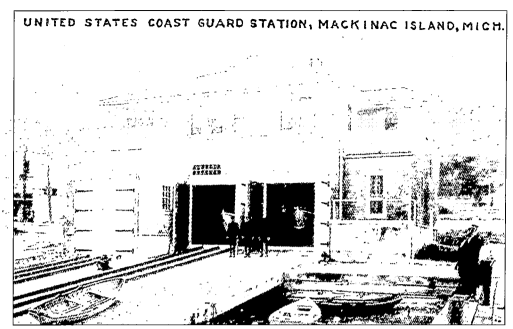

This close-up postcard view of the Coast Guard station on Mackinac Island, shown from the water, details the ramps that allowed such a boathouse facility to be used. From here, Coast Guard boats went out to assist distressed ships. Through the open overhead doors, boats can be seen housed within. (Courtesy of Armand "Smi" Horn.)

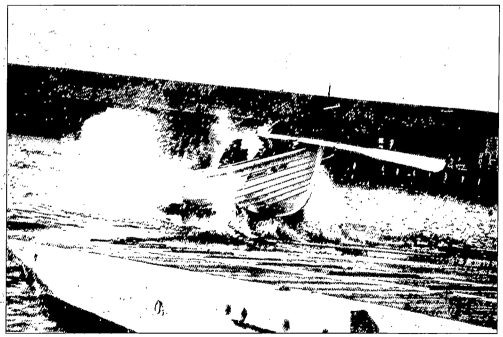

The use of these ramps is demonstrated in this picture of a lifesaving boat coming ashore through the waves. The unique design of the Coast Guard's lifesaving boats allowed them to be operated in heavy seas and to reach sailors and ships in trouble. They were used very successfully throughout the upper Great Lakes. (Courtesy of Tom Pfeiffelmann collection.)

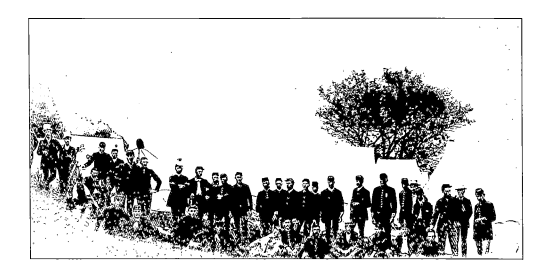

Shown above is a Michigan National Guard unit on Mackinac Island in 1887 for maneuvers. The men posed for this photograph in their encampment in one of the Army pastures. In the summers of the 1880s and 1890s, National Guard personnel came from around Michigan, as well as Indiana and Ohio, to participate in such training. Sometimes the encampments were set up on the more spacious Early farm in the island's center. Below, also in 1887, members of the same unit are shown gathered in their mess tent. The woman is most likely the wife of a ranking officer. At least 500 or more guardsmen participated in those summer drills, which sometimes were jointly held with Fort Mackinac soldiers. (Courtesy of Clarke, Trelfa.)

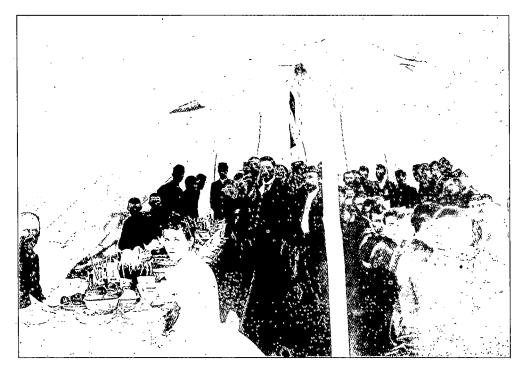

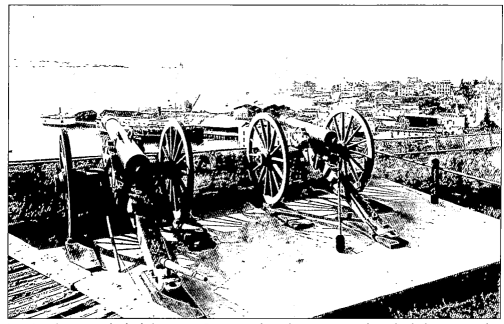

Fort Mackinac overlooked the entire Straits, and its elevation proved too high for cannon fire from a ship to reach. The British originally nicknamed the fort "Little Gibraltar of America." As the last frontier disappeared, along with the fur trade, so did the fort's military significance. (Courtesy of Tom Pfeiffelmann collection.)

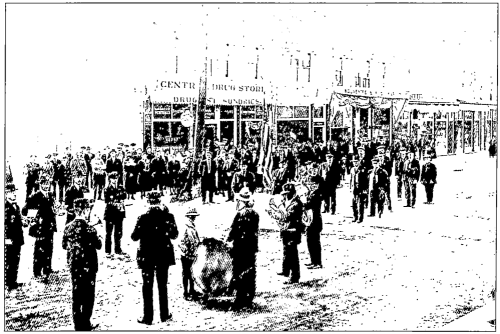

Mackinac Island has sent its best to serve in the nation's armed forces throughout the world. A number of local service members made the ultimate sacrifice and are honored by a memorial in a small city park off Market Street. Here, the scene is a sendoff of Mackinac Island men as they leave to protect freedom in World War I. (Courtesy of Doud.)

Four

CHURCHES AND

PUBLIC BUILDINGS

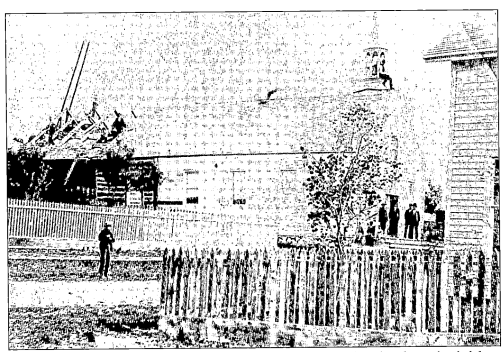

Shortly after Fort Mackinac was built in 1780, St. Anne's Catholic Church was hauled from Mackinaw City across the ice to the island and came to rest on the east side of Hoban Street. Lt. Gov. Patrick Sinclair correctly surmised that the fur-trading community's people would follow their church. A second St. Anne's Church later built on the site is shown in 1873 during its demolition. The man on the belfry is Walter Murray. (Courtesy of Tom Pfeiffelmann collection.)

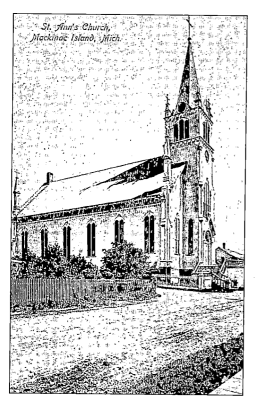

In 1874, this new St. Anne's Church opened on Huron Street on land donated by Madame Magdalaine La Framboise, who had inherited and sold her husband's fur business. The tower and steeple were added in 1890–1891. Fr. Claude Dablon had wintered on the island in 1670–1671 in order to build the Bark Chapel, the island's first Catholic mission. Father Marquette followed that spring with Huron Indians, but poor crops rendered settlement temporary. (Courtesy of Madelyn Le Page.)

St. Anne's Catholic Church is shown here about 1940 from the viewpoint of the David Murray home across Huron Street. The building to the right is the church's parsonage. St. Anne's and the other churches have long been popular locations for summer weddings. Honeymoons at the island's beautiful hotels and traveling by horse-drawn carriage add to the romantic aura. (Courtesy of Tom Pfeiffelmann collection.)

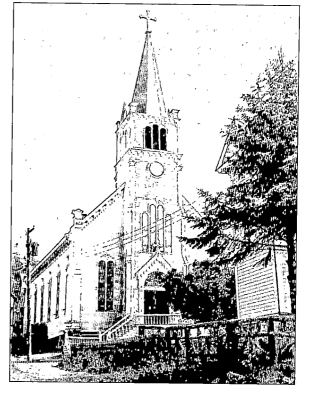

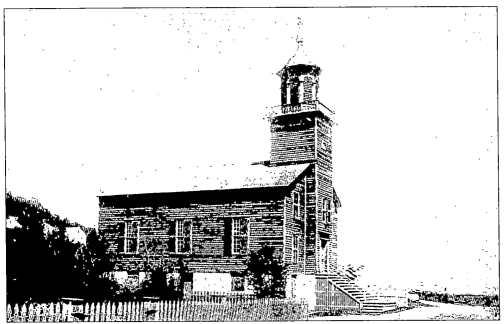

Also on Huron Street, Old Mission Church, constructed in 1829, was named for its service as a mission to Mackinac Island's Indians. Much of the history of European and later American exploration of the upper Great Lakes resulted from the introduction of Christianity to Native Americans. Mission Church is the oldest extant church building in Michigan. This undated photograph is clearly very old, given the lack of surrounding structures. (Courtesy of Madelyn Le Page.)

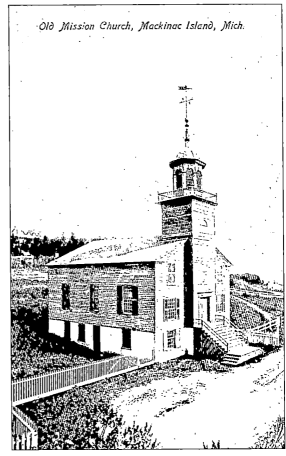

Old Mission Church, Mackinac Island, Mich.

Old Mission Church's location near Mission Point has been significant, as many of the island's mission activities have been based out of structures in that southeast area. In 1955, the church was given to the Mackinac Island State Park Commission (predecessor to Mackinac State Historic Parks) and has been restored. It is open for summer visits and is still used for events such as weddings and funerals. (Courtesy of Armand "Smi" Horn.)

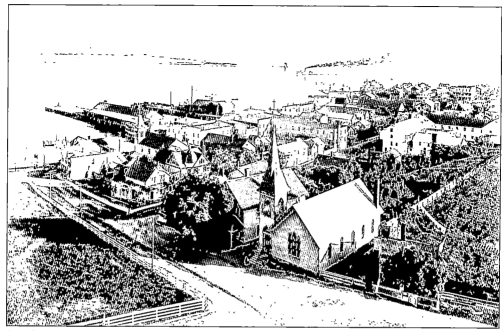

Small and photogenic Trinity Episcopal Church is centered in these shots taken from Fort Mackinac. Constructed in 1882 on Fort Street (in order to be near the garrison), Trinity has for years been the only year-round Protestant historical church on Mackinac Island. The corners of the Fort Mackinac post gardens and pastures are seen to the right and left in these photographs. Beginning in 1837, island Episcopalians first used Mission Church, then a chapel in Fort Mackinac, before finally building this church. Above, in the background, a ship has made its way past the Round Island Lighthouse, which was still in use. The large hotels had not yet been built. Below, one of the pastures and Astor Street extend outward from the photographer's viewpoint. (Courtesy of LOC, numbers 4a03672u and 4a06838u.)

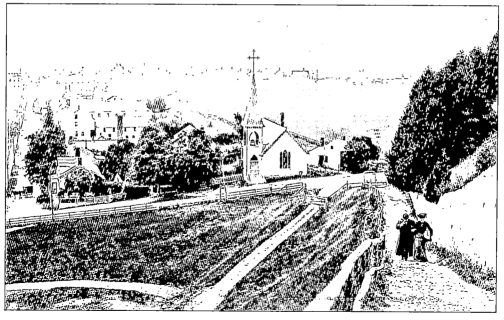

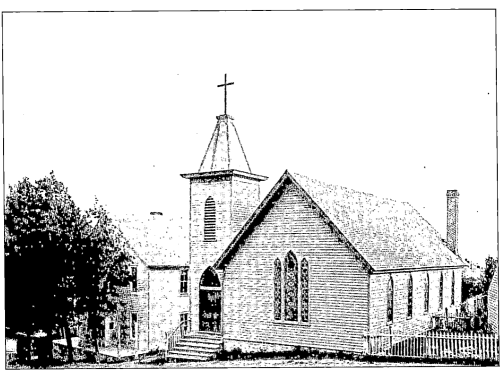

Other than vents added to the bell tower, this older and closer view of Trinity Episcopal Church shows little change. All four of Mackinac Island's historical churches still appear much as they did when constructed, especially from the exterior. Additionally, the missionary Bark Chapel, which was used in 1671 and then abandoned, was rebuilt as a park exhibit across Fort Street from Trinity. (Courtesy of Tom Pfeiffelmann collection.)

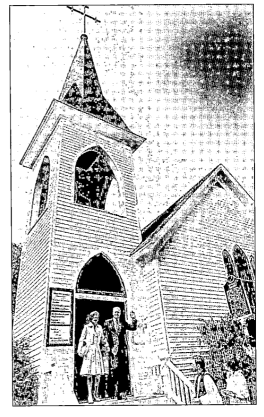

In 1975, Pres. Gerald Ford and First Lady Betty visited Mackinac Island, a rare event for a sitting president. On July 13, they attended services at Trinity Episcopal Church and are shown waving as they left. One of the largest crowds of day visitors in Mackinac Island history greeted the president—a Michigan native—and first lady during that visit. (Courtesy of Tom Pfeiffelmann collection.)

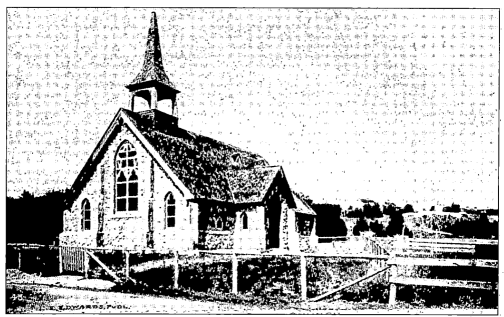

Deacons J.M. Leggett and S.B. Poole helped to found and set the cornerstones of the Union Congregational Church, also known as the Little Stone Church, which was built on Cadotte Avenue in 1904 of local fieldstone. This summer-only Congregational church, with stained-glass windows depicting island history, has hosted many weddings. In 1980, the author regularly punched out from work on adjoining Grand Hotel Golf Course, parked the tractor he was riding, and attended Sunday services, prompting the minister to proclaim him the only person ever to drive to church on Mackinac Island. (Courtesy of Madelyn Le Page.)

Shown is an undated but clearly old photograph of the interior of Trinity Church. Like those of Old Mission and Little Stone Church, Trinity's sanctuary is fairly simple and humble. It is accentuated throughout by natural wood, fitting the rustic character of Mackinac. The altar is made of hand-carved walnut, and there are still two chancel chairs made by Fort Mackinac soldiers. (Courtesy of Bentley, Poole folder 13.)

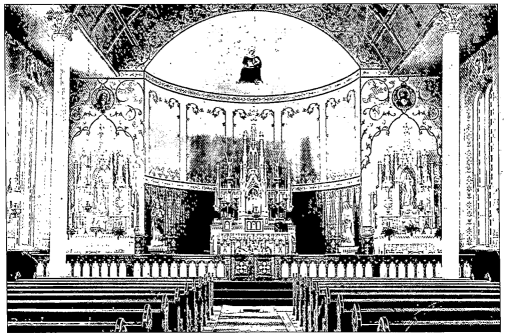

This undated image shows the interior of the large and ornate sanctuary of St. Anne's Catholic Church as it appeared before 1996, when the building underwent a renovation but retained its basic character. The largest of the island's four historical churches, St. Anne's continues to be the focal point of many community activities. (Courtesy of Bentley, McIntire, Mackinac Island Buildings folder.)

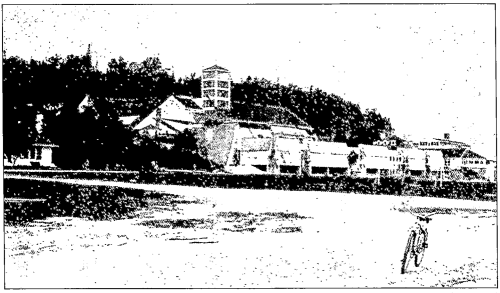

Beginning in 1954, Mackinac Island's Mission Point became the construction site of the Moral Re-Armament (MRA) complex. MRA was a Christian organization led by Dr. Frank Buchman. The facility was sold to the founders of Mackinac College in 1966. The complex included the Great Hall (with a vaulted log ceiling), a theater, and dormitories for hundreds of people. (Courtesy of Tom Pfeiffelmann collection.)

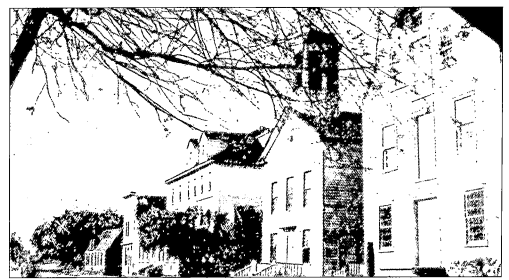

This image shows city administrative buildings on Market Street. The first structure in the foreground is the city hall/community center (formerly the American Fur Company Warehouse built in 1810), and to the left is the courthouse (built in 1839). Further to the left, the Lenox Building, which was constructed in 1887, now houses the private offices of Carriage Tours. Not shown, but nearby, are the Stuart House (built in 1822, formerly a fur agent's house and now the city's museum), the fire hall, and a new medical center. (Courtesy of Armand "Smi" Horn.)

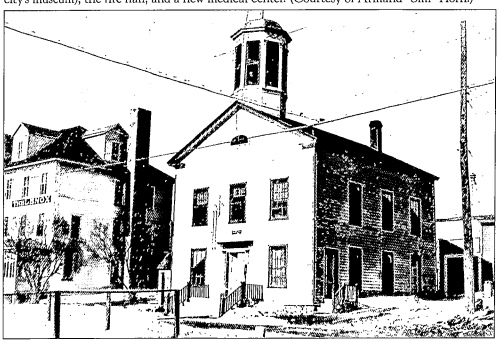

This is a 1950s view of the courthouse, which has not significantly changed. Mackinac Island was the seat of Mackinac (previously Michilimackinac) County until 1882, when the seat was moved to St. Ignace. The historic courtroom on the second floor was the scene of the famous 1859 People v. Pond murder trial. The appeals led the Michigan Supreme Court to hold that "a man's house is his castle." (Courtesy of Tom Pfeiffelmann collection.)

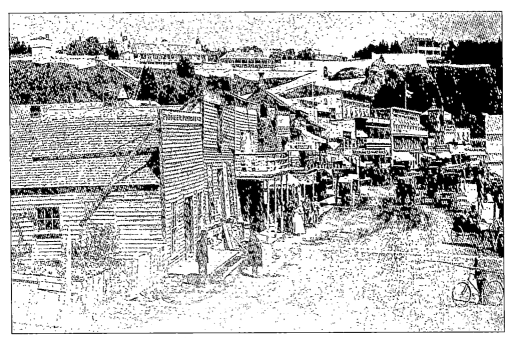

An 1895 photograph looking to the east down Main Street shows the Pioneer Post Office in the foreground. The second-to-last building on the left is Foley's Store, which sold souvenirs and also contained an art gallery. It was one of the island's main retailers of the era. (Courtesy of Bentley, Poole folder 1.)

This 1923 image reveals that the Mackinac Island Post Office appears to be situated in the same location as the Pioneer Post Office had been, but in an improved and better-maintained building. In the interim, early in the 1900s, the post office had been moved to a location near the US Custom House, but it was moved back before this picture was taken. (Courtesy of Tom Pfeiffelmann collection.)

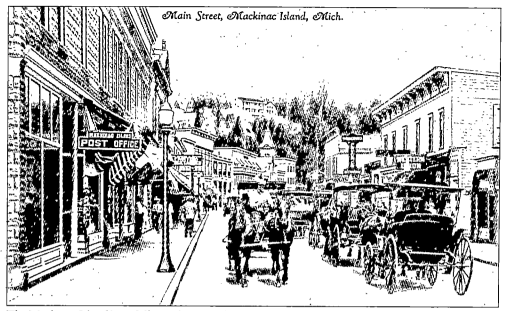

The Mackinac Island Post Office is shown with further building improvements. Faster communications had also become available—right across the street at the Western Union office. Beginning with an underwater wire in 1883, telegraphs could be sent and received. The island's current post office was built in 1959 on the former Market Street site of the American Fur Company's clerk's quarters. (Courtesy of Armand "Smi" Horn.)

In 1945, the State of Michigan purchased the Young family's house for $15,000, and it has served as the part-time summer residence of the state's sitting governor and family. This perk has been the envy of governors nationwide. Michigan has smaller—but still substantial—cottages just east of this location that lodge other state officials during business trips. (Courtesy of Archives of Michigan.)

In 1870, the Indian Dormitory became the William Ferry School, which educated Mackinac Island's children. The school was located just east of Marquette Park on Huron Street. It served the island in this capacity until 1960, when the current school was constructed on land donated by the Grand Hotel, situated just below the hotel proper. (Courtesy of Tom Pfeiffelmann collection.)

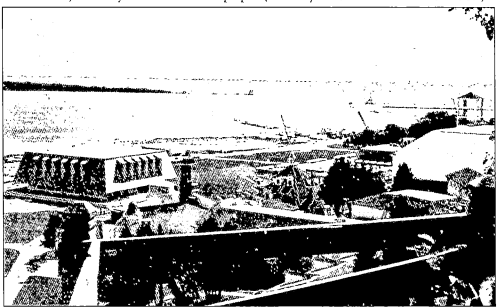

In 1966, Mackinac College opened with 16 faculty members and 113 students. It grew, graduating 30 of its students in 1970, but then closed that summer due to logistical and financial hurdles. A year later, there was an unsuccessful attempt by evangelist Rex Humbard to restart Mackinac College. Mission Point became a large resort in 1977 and is still in operation today. (Courtesy of Tom Pfeiffelmann collection.)

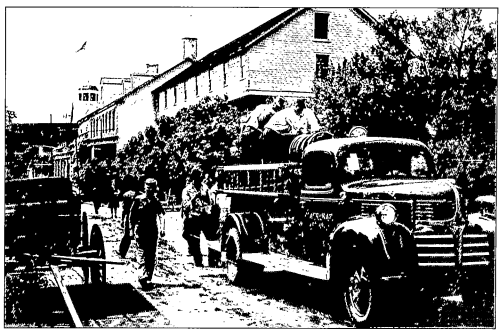

The ban on motor vehicles on Mackinac Island does not apply to public emergency vehicles. Accordingly, Mackinac Island has maintained modern ambulances, city police vehicles, and a fleet of fire trucks. This image depicts a 1940s Mackinac Island Fire Department truck, very possibly the island's first. Essential maintenance, construction, and delivery trucks have also been allowed by special permit, especially during the off-season. (Courtesy of Tom Pfeiffelmann collection.)

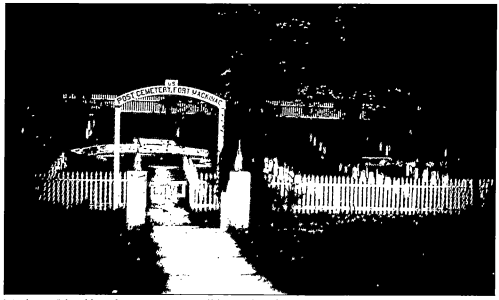

Mackinac Island has three cemeteries, all located in the same general area along Garrison Road. This photograph shows the Post Cemetery, reserved for Fort Mackinac soldiers from the War of 1812 through the 1890s. Most of the over 100 graves contain the remains of Americans, although the cemetery probably also holds several British soldiers. The other cemeteries are designated as Catholic and Protestant and date back to the 1850s. (Courtesy of Tom Pfeiffelmann collection.)

Five

THE TOWN AND

ITS PEOPLE

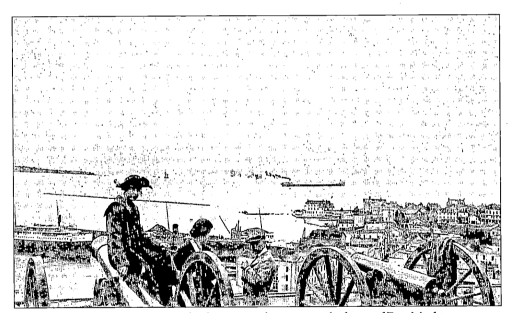

This group, shown in 1917, is not the first to use the cannon platforms of Fort Mackinac to pose for a picture. The vantage point overlooks the City of Mackinac Island, located around Haldimand Bay at the south end of the island. While the City of Mackinac Island and the island itself are often spoken of synonymously, the city actually occupies only about 20 percent of the island. (Courtesy of Tom Pfeiffelmann collection.)

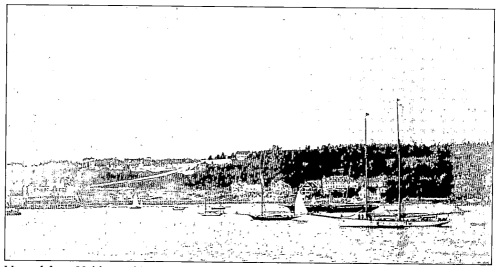

Viewed from Haldimand Bay in 1906, the eastern area of the City of Mackinac Island has primarily been constituted of hotels, residences, and churches. The inner harbor as shown has been the primary anchorage point for private boats that do not need use of the larger piers and docks to the west. The downtown district extends west from the Chippewa Hotel. (Courtesy of Mackinac Island Library.)

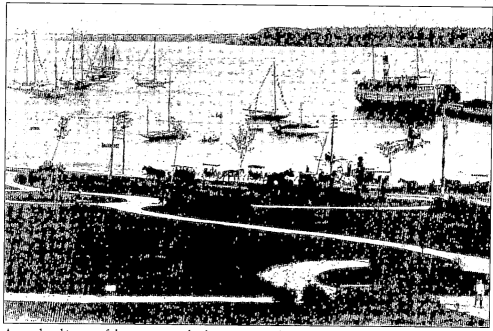

An undated image of the same inner-harbor area was taken from the upper part of Marquette Park below Fort Mackinac. This picture captures the confluence of numerous private sailing vessels and horses and carriages, as well as a steamship. The fur-trading community established below Fort Mackinac by the British later became a borough with a government in 1817. (Courtesy of Tom Pfeiffelmann collection.)

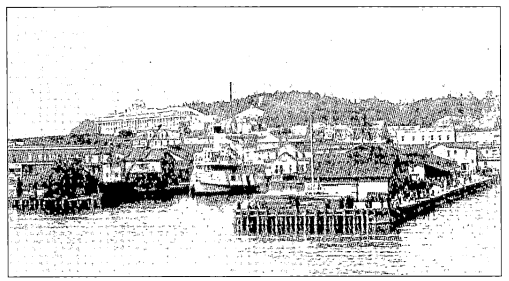

The main shipping docks have been essential to Mackinac Island for the transport of people and the delivery of provisions. The coal dock is to the left, and to the right is Union Terminal Pier, the largest terminus for ships and ferries. The Grand Hotel, shown in the upper left portion of the image, appears to be downtown but is actually atop West Bluff. (Courtesy of Tom Pfeiffelmann collection.)

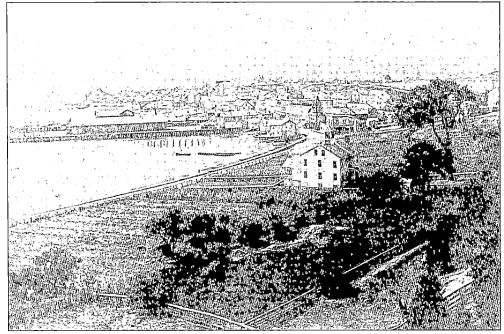

A 1890s overlook of the City of Mackinac Island from East Bluff takes in the post gardens and pastures below Fort Mackinac that surrounded the Indian Dormitory, which is shown in the foreground. This image encompasses almost the entire city as it existed at the time, with the exception of St. Anne's Church, Old Mission Church, the Mission House, and homes to the east, all of which were to the left of what is captured in this photograph.

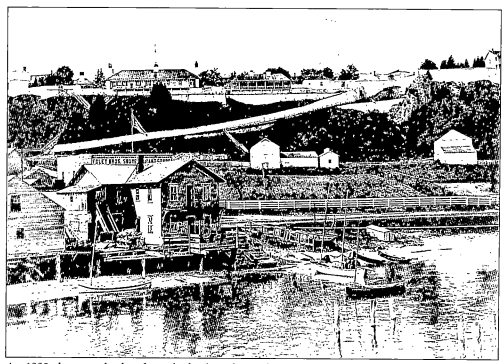

An 1893 photograph, shot from the harbor, shows the area of Fort Mackinac before construction of the Chippewa Hotel at the site of the US Custom House, also the customs agent's home (on the beach at left). The Fort Mackinac post garden was still in use at the time. The top of Foley's Store can be seen in what is now the location of Doud's Market, Michigan's oldest family-owned grocery.

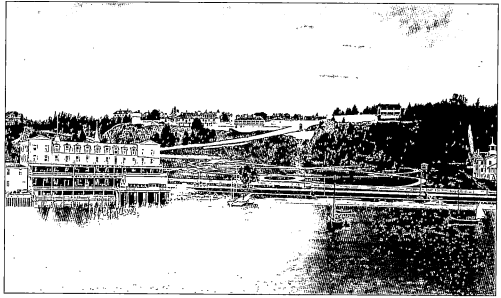

Contrasted with the image above, this photograph of the same area, taken about 10 years later, reveals that the former Army garden was by then a park (although not yet dedicated as Marquette Park) and that the Chippewa Hotel had been built.

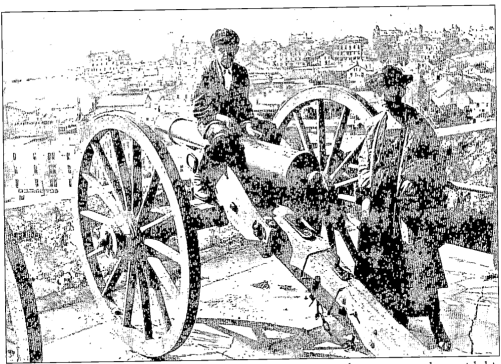

This image is included for the poignancy of the boy posing on the cannon, perhaps with his mother, in early-20th-century-era clothing. The City of Mackinac Island, seen below the pair, was governed by a city council and mayor and was incorporated with the State of Michigan as a municipality in 1900. (Courtesy of Clarke, Trelfa.)

This group of men is posed in 1895 on one of the piers of Mackinac Island. Many Mackinac Islanders have been employed in connection with maritime-related activities, such as serving on the ferry or freight boats, working on the docks, or commercial fishing. In the mid-1800s, the piers and nearby streets were the locations of the fish-processing businesses that sorted, salted, and packed up to 25,000 barrels of fish per year.

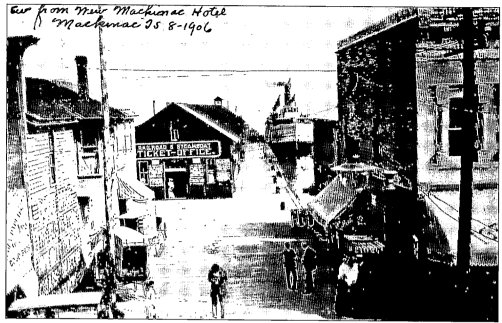

A 1906 view, captured by a tourist visiting the island, was taken from a second-story window of the New Mackinac Hotel looking toward the Union Terminal Pier across Huron Street. The New Mackinac Hotel no longer exists, and in that location are the Mackinac Island Tourism Bureau, Carriage Tour ticket office, and a small city park. (Courtesy of Mackinac Island Library.)

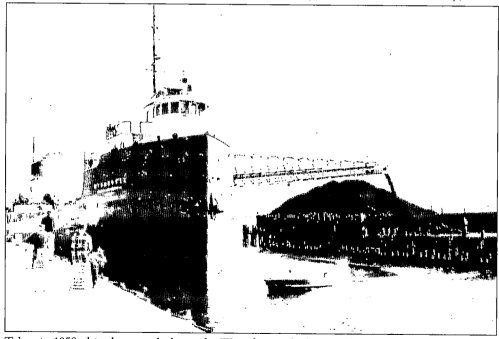

Taken in 1958, this photograph shows the *Wyandotte*, a fairly typical Great Lakes freighter of the era, docked on the west side of Union Terminal Pier and unloading coal across to the coal dock. Coal was used to refuel steamships. Great Lakes freighters now are built to exceed 1,000 feet in length, but they are still in a similar design. (Courtesy of Tom Pfeiffelmann collection.)

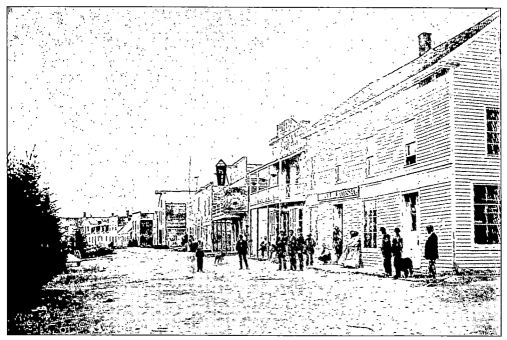

The following dozen images highlight Mackinac Island's main street—Huron Street. This is one of the oldest photographs of the island, taken about 1870. It shows the island before the south (left) side of the street was developed along the shore of the harbor toward that west end of town. The Bromilow, Bates & Co. general merchandise store and the Indian Bakery were among early downtown retailers. (Courtesy of Mackinac Island Library.)

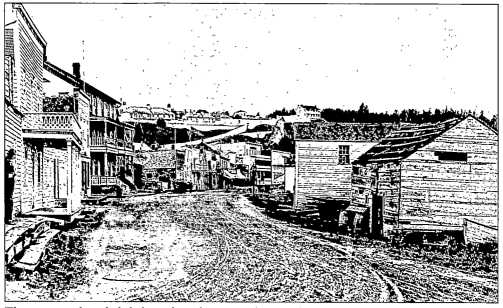

This image, taken slightly later than the image above, is from the same area of Huron Street but toward the east. These photographs of Main Street are arranged chronologically as much as possible in hopes that the reader will enjoy seeing changes that occurred over the years. By the time this picture was taken, development of the shore side of the street, to the right, had begun.

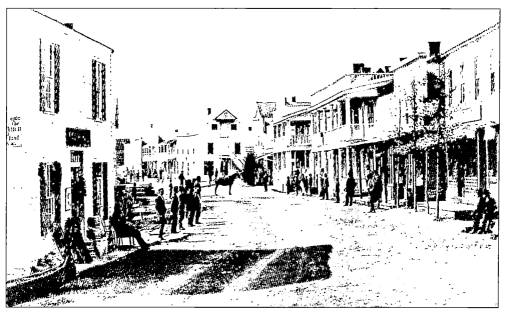

This 1875 view looks toward the west from the front of the US Custom House, which was built in 1846 as a simple home. The customs agent was Jacob Wendell. A store was later operated from the house. In these early Main Street frames, note the absence of bicycles and even the lack of many horses. Most transportation was apparently accomplished on foot, and there was a more significant pedestrian presence as the number of retailers increased.

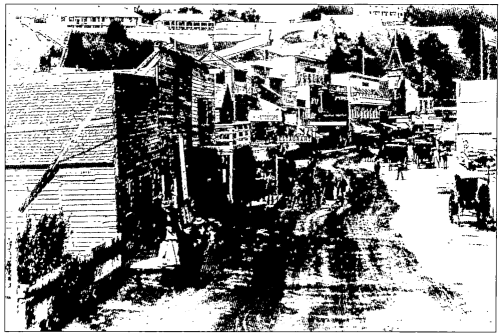

A photograph of Main Street in 1900 depicts the clothing styles of the people at the time and also shows increasing horse and carriage traffic, as well as more retail outlets. Coupled with the architecture and Fort Mackinac hovering above, the scene has an Old West feel, even though it is located east of the Mississippi River. (Courtesy of Tom Pfeiffelmann collection.)

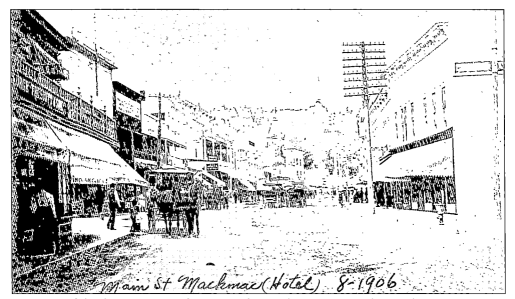

A picture of the downtown area from around 1900 shows more retailers, such as Bogan's Drug Store. Former Army officer Charles Fenton's National Park Indian Bazaar continued in business for years after the island was no longer a national park. It sold goods ranging from cigars and maple syrup to souvenirs and curiosities. The 1872 building had an opera house on the second floor for a time. (Courtesy of Bentley, Tanner box 14.)

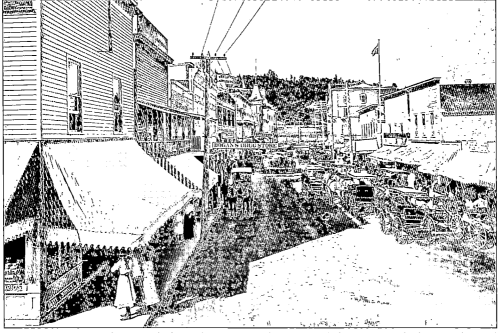

This 1906 tourist's photograph from the New Mackinac Hotel shows new telephone poles and lines. The Mackinac Island Electric Light and Telephone Company was the first local utility system. Water was pumped from springs until 1901, when a reservoir was built near Fort Holmes. The island has had electricity since that year, first supplied by a small generating plant and now by underwater cables from the mainland. (Courtesy of Mackinac Island Library.)

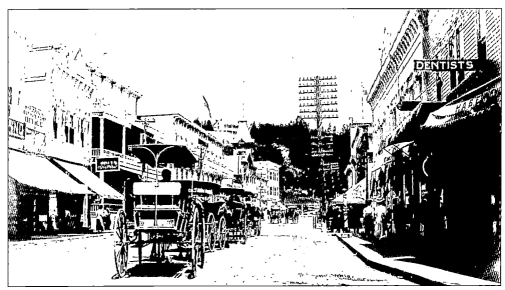

Later in the 20th century, retail establishments, transportation, and clothing styles on the island became more refined. At least since World War II, most year-round residents (between 400 and 800 people at various times) have lived in the unincorporated settlement of Harrisonville (named for Pres. Benjamin Harrison) in the island's center rather than in the City of Mackinac Island. Most homes that are in the city are outside the business district. (Courtesy of Madelyn Le Page.)

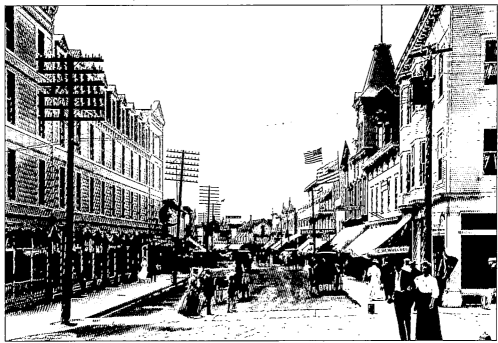

This view, taken prior to 1923, is toward the west of the downtown district. The Chippewa Hotel is on the left, and on the right is the tallest building shown, Fenton Hall. While Main Street became increasingly busy in the summers as the 20th century progressed, only a handful of businesses have remained open throughout each year to provide the basic necessities to residents. (Courtesy of LOC, number 4a24672u.)

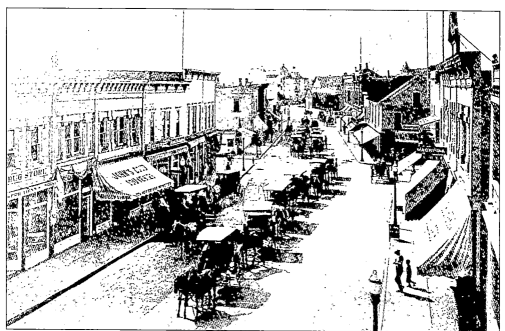

The increase in horse and carriage traffic and the corresponding congestion of downtown is apparent in these two images of the same stretch of the main street. Based on the clothing styles and the appearance of city lampposts, these photographs were most likely shot later than the previous series. The telegraph and telephone lines had been buried by this time. Bicycle traffic was still nowhere to be seen. Huron was still a dirt street, although smoothly maintained. Traffic on Huron Street has always been most crowded downtown, although in summer months it is not unusual for there to be congestion extending onto highway M-185 all the way around the island. (Above, courtesy of Armand "Smi" Horn; below, courtesy of Bentley, Visual Materials.)

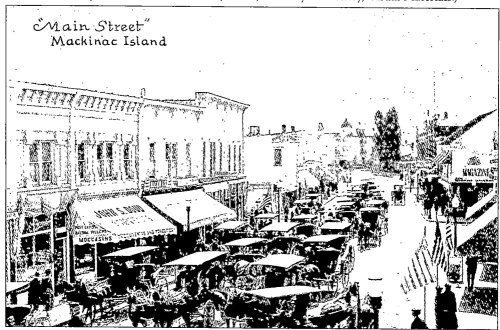

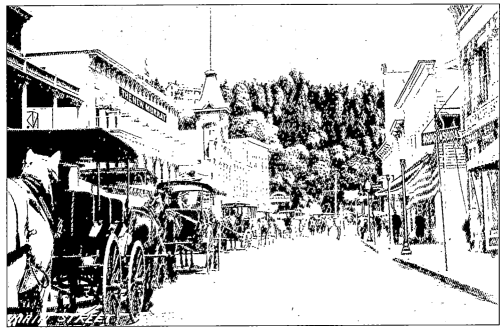

The east end of downtown is shown a bit later in the early 20th century after construction of the New Murray Hotel. Huron Street appears to have been paved. By this time, private automobiles had largely replaced horses on mainland roads but will never do so on Mackinac Island due to the permanent ban. (Courtesy of Madelyn Le Page.)

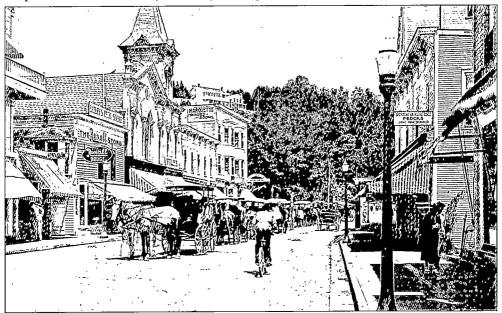

By the 1920s, bicycles competed with horses on the streets. The Rexall Drug Store was run by Dr. John Bailey, former island and fort doctor, who also served on the state park commission. Mackinac Island has for the most part rejected national franchise businesses and enacted strict codes in order to maintain its historical character. Beginning with Murdick's in 1880, fudge shops have proliferated downtown and continue to do so today. (Courtesy of Madelyn Le Page.)

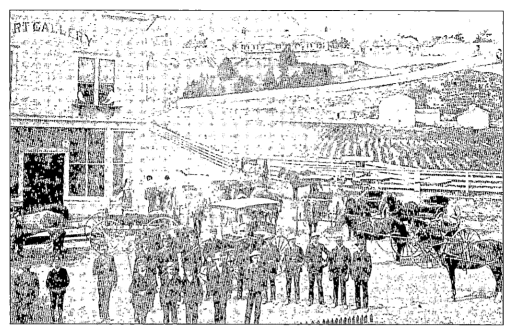

These 1880s "carriage hawkers" posed in front of the Army farm and Foley's art gallery and souvenir store on what would be the future site of the Marquette Hotel and Doud's Market (the latter in business now for over a century). As tourists alighted from ferries and ships, hawkers called out from the nearby street, competing with one another to sell carriage rides, including narratives of the sights. Foley's burned in 1895.

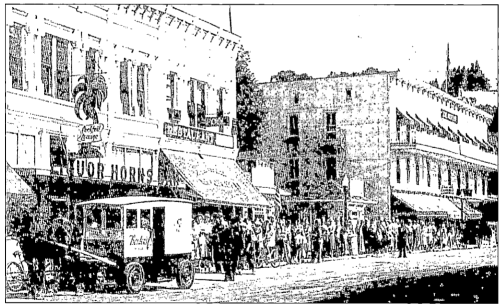

In a seeming contradiction, a horse-drawn Borden's milk wagon is shown passing or stopping in front of Horn's Cocktail Lounge. In 1933, Horn's was one of the first taverns licensed to open after the end of Prohibition. With its hotel and tourism industry, Mackinac Island has been a successful location for many seasonal restaurant and beverage businesses. (Courtesy of Tom Pfeiffelmann collection.)

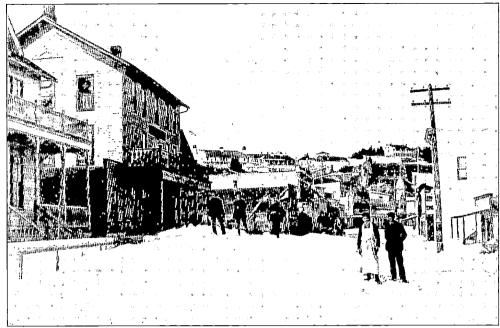

Located north of the 45th parallel, Mackinac Island's average annual snowfall exceeds 100 inches, there can be very strong winds, and temperatures drop far below zero at times. This explains the very seasonal nature of island business. Most residents work long hours half of the year, but there are very few year-round businesses or jobs. (Courtesy of Tom Pfeiffelmann collection.)

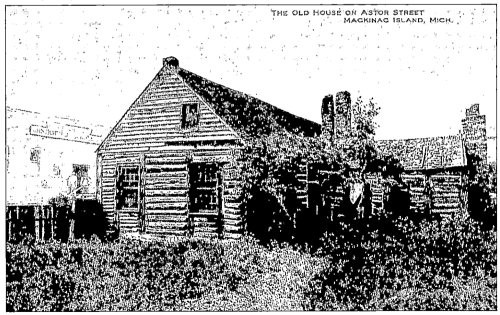

This 1907 postcard shows the oldest house on Mackinac Island, built about 1780 and bought by village president, fur trader, and fisherman Edward Biddle in 1827. Island residents' homes in that era were often in disrepair due to a lack of time or money. This house, situated on Market Street, is now restored and belongs to the parks, as does a nearby blacksmith shop that operated from the 1880s to the 1960s. (Courtesy of Petosky.)

In 1946, Fenton Hall's tower was demolished for safety. This photograph was taken for posterity as removal began. Located on Main Street's east end, the tower is easily recognized in many images taken from about 1872 on. The building contained Fenton's Bazaar, an early tourist gift store, and was situated on the previous site of the Northern Hotel, which was constructed with logs and reportedly built in 1810. (Courtesy of Bentley, Poole folder 13.)

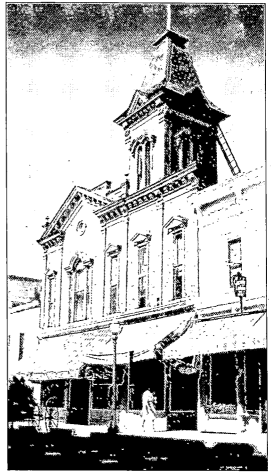

Another often photographed Mackinac Island home was the Mitchell house, built about 1780. David Mitchell was a British surgeon's mate at Fort Mackinac and the only doctor in the upper Great Lakes at one time. He married an Indian woman named Elizabeth. This home was one of the more elaborate of island society when built, but it eventually fell into disrepair. (Courtesy of Tom Pfeiffelmann collection.)

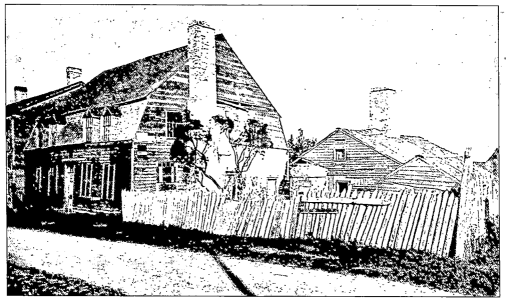

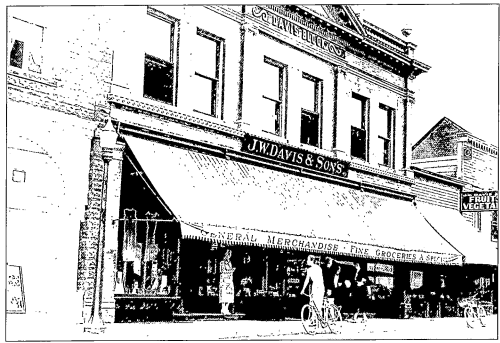

In the heart of Mackinac Island's downtown, on Main Street, the Davis building contained the J.W. Davis Store, established in 1870, which sold groceries and general merchandise. The building was reconstructed in brick in 1898 and again in the late 1980s after a fire. The exterior view, seen above in 1914, shows that it was not a large store by big-city standards. But the 1927 photograph of the interior shown below reveals that a lot of merchandise was packed into the space inside. The produce was of high quality, good enough to draw shoppers from the mainland. (Courtesy of Tom Pfeiffelmann collection.)

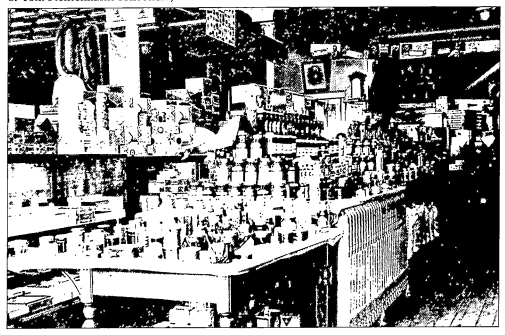

Workers and relatives are seen posing in front of the late-1890s Island Steam Laundry with its delivery carriage. The laundry, previously owned by the Witmer brothers, was located along the harbor, west of the Union Terminal Pier. At that time, there was still a vacant lot next door (seen to the right); the building to the left was new.

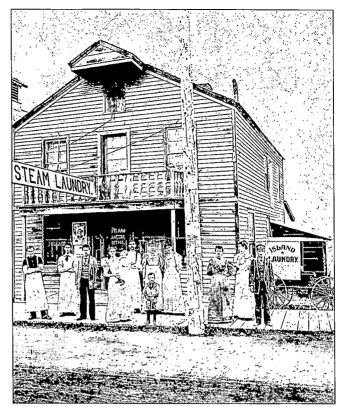

During the fur-trade years, the primary commercial street was Market Street, directly below the protection provided by Fort Mackinac and inland from Huron Street. It appears that as the commerce base shifted to fishing industries, retail also moved to Huron Street, closer to the docks. Today, Market Street still has substantial businesses and government buildings, while the prime retail space is on Huron Street. (Courtesy of Tom Pfeiffelmann collection.)

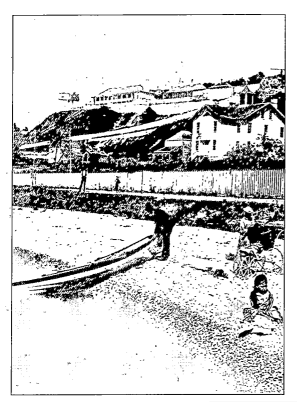

This striking image dates back to the 1860s and was taken on the beach of the harbor, just east of Fort Mackinac and the Indian Dormitory. As the man attends to the boat onshore, a small Native American child plays on the beach. This is the location where the island's marina was later constructed. (Courtesy of Metivier Inn.)

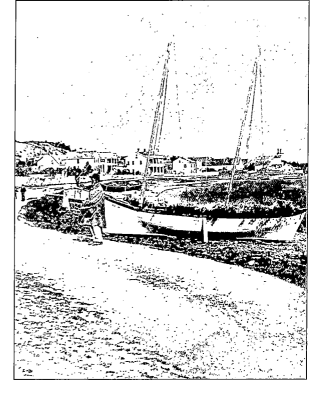

This view of the same shoreline, taken in the late 1870s, looks east. In the background, the Indian Dormitory, Island House Hotel, and the newly constructed St. Anne's Catholic Church can be seen. The boat beached in the foreground, possibly unseaworthy, may have been in use as a unique type of planter or garden.

Mackinac Island has had motorized emergency vehicles for most of the past 100 years. Use of horse-drawn emergency vehicles continued later on the island than on the mainland. This ornate fire wagon was probably used until the early 1900s. Police on the island periodically use bicycles and horses to this day (in addition to a sport utility vehicle). (Courtesy of Bentley, Poole folder 14.)

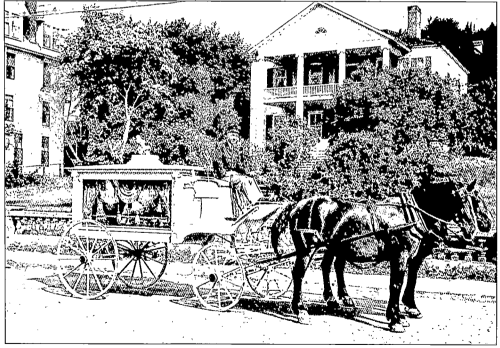

With the exception of some maintenance trucks, island commercial vehicles have continued to be horse drawn, and carriages of one sort or another are used on a daily basis. Shown as an example is this horse-drawn hearse. Most anything that has to be moved or hauled, from taxi passengers to the island's household refuse, goes by way of carriages. (Courtesy of Bentley, McIntire Mackinac Island Buildings folder.)

Horse plows were once used to clear the Mackinac Island streets of snow, which can sometimes be very deep. This team of plows was used in tandem. Plow-truck usage began in 1947 as a better way to keep roads clear for fire trucks. (Courtesy of Tom Pfeiffelmann collection.)

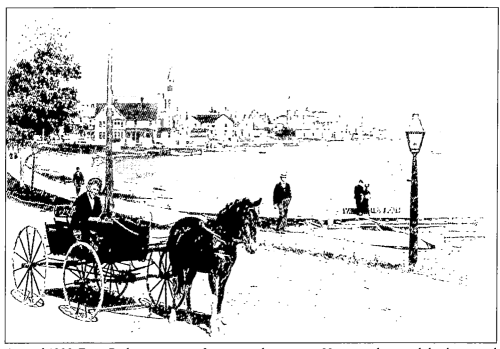

Around 1900, Ernst Putkammer was a frequent sight in town. He is seen here with his horse and cart. A number of Mackinac Island year-round and summer residents keep horses, with or without carriages or buggies. Most of the island's horses have been seasonally transported to and from the island on ferry and freight boats. (Courtesy of Tom Pfeiffelmann collection.)

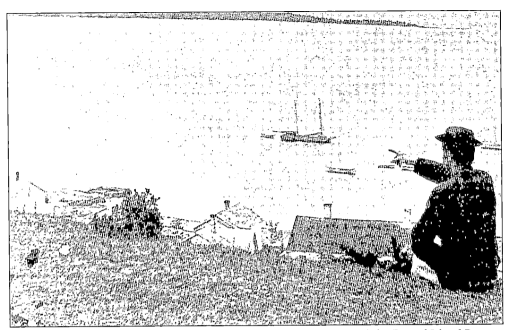

In this image from the late 1800s, an unidentified man points toward the Round Island Passage from the bluff overlooking the harbor and City of Mackinac Island. This next series of photographs will illustrate changes in the town's appearance from the vantage of these bluffs, which also offer classic views. (Courtesy of Tom Pfeiffelmann collection.)

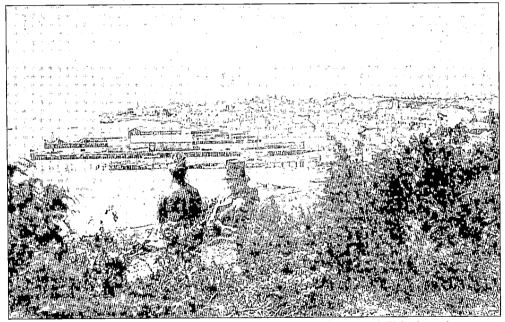

In the late 19th century, this unidentified couple relaxes on the East Bluff, looking down upon the harbor, docks, and City of Mackinac Island. Note that the town had not yet been developed very far to the east, nor up onto the bluff areas, and was primarily limited to the downtown district. A third major pier existed west of Union Terminal Pier and the coal dock. (Courtesy of Tom Pfeiffelmann collection.)

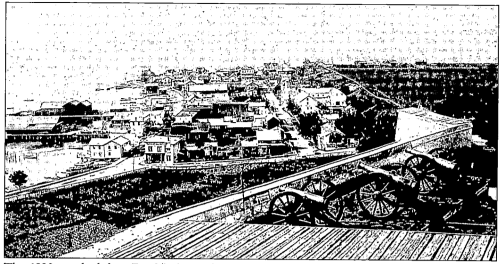

This 1890s overlook from Fort Mackinac shows no people, only the compact little City of Mackinac Island surrounded by the cow pastures of the Fort Mackinac post gardens. Only pilings remained from the westernmost pier mentioned in the previous caption. Huron Street extends along the harbor to the left, and Astor Street is seen running parallel to it.

The lack of many structures yet built below Fort Mackinac is apparent in this 1880s image of the large, undeveloped parcels of land around the town. The ravine below East Bluff later became mostly concealed by the construction of many residences on top of and below the bluff. The boy's dog is camouflaged among the undergrowth.

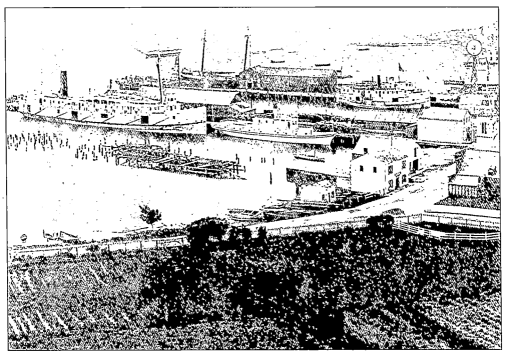

Another 1890s view of the inner harbor from atop Fort Mackinac depicts heavy usage of the remaining two major piers. By 1907, seven steamship lines made calls at Mackinac Island. Ships had to anchor in the harbor, awaiting space at a dock to set ashore passengers and freight.

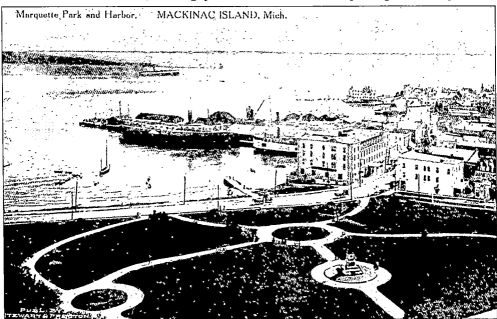

Marquette Park and Harbor. MACKINAC ISLAND, Mich.

In contrast to the previous image, by the time of this 1911 photograph taken from Fort Mackinac, Marquette Park had replaced the post gardens. The Chippewa and Iroquois Hotels had been built and opened, and more stores appeared downtown. Ship traffic remained heavy during this period. Piles of coal gave the coal dock its common name. (Courtesy of Armand "Smi" Horn.)

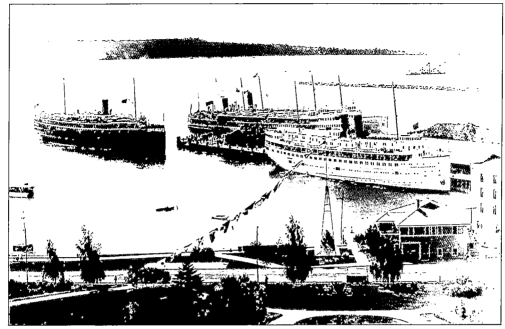

By about 1920, Marquette Park had been spruced up even more, and the Coast Guard station had been built next to the Chippewa Hotel. Four passenger steamships vied for very limited docking space at the Union Terminal Pier. The two ships on the west side of the dock were "rafted off" from one another, probably requiring passengers of the more remote ship to disembark onto the other before going ashore. (Courtesy of Tom Pfeiffelmann collection.)

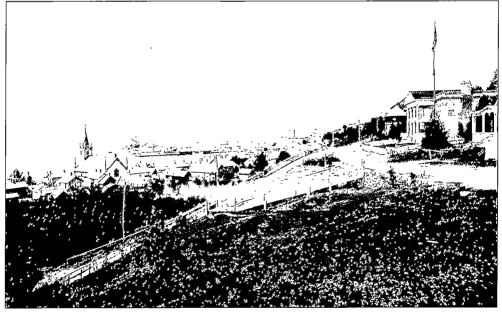

This early-20th-century image captures the view of the City of Mackinac Island from the East Bluff and behind St. Anne's Church after some of the residences of the bluff had been constructed. The street heading down the bluff to the left provides access to the bluff from Mission Point without having to go all the way around Fort Mackinac. (Courtesy of LOC, number 4a03673u.)

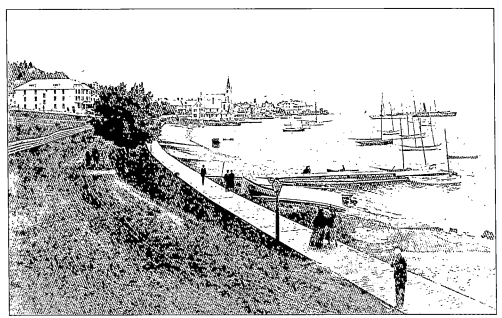

Images from about the turn of the 20th century illustrate that while steamships needed the piers to dock, sailing vessels favored anchorage in the east harbor below the fort. A boardwalk along the dirt street provided a cleaner path for pedestrians to enjoy their walks until modern sidewalks were extended from downtown. However, a boardwalk has remained—from the west end of downtown to just below the Grand Hotel property along the lakeshore—for viewing the world-famous sunsets over Lake Michigan and the Straits of Mackinac to the west. The image above was taken after the 1907 addition of city lampposts. (Above, courtesy of Clarke, Main; below, courtesy of Bentley, Tanner box 14.)

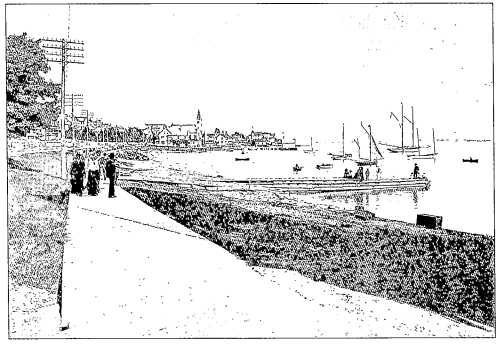

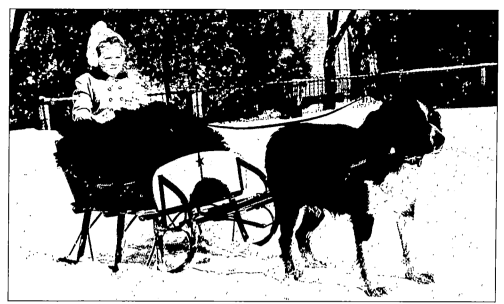

The little girl in the dog sled is Margaret Doud, who grew up to be elected as mayor of the City of Mackinac Island for a record number of one-year terms, beginning in 1975 and continuing today. Her father, Robert, served on the city council and then served as mayor. (Courtesy of Tom Pfeiffelmann collection.)

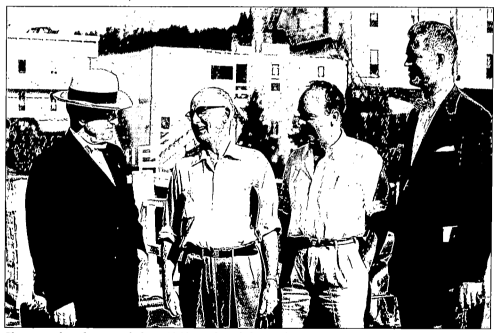

Shown in this photograph from 1955 are, from left to right, former president Harry Truman, local businessmen Otto Lang, Hugh Rudolph, and Michigan governor G. Mennen "Soapy" Williams. The shot captured them on an island boat dock during a political convention. Williams loved his time in the governor's mansion, and after leaving office purchased a magnificent West Bluff cottage. A successor, Gov. William Milliken and his wife, Helen, built a West Bluff summer residence after retiring. (Courtesy of Tom Pfeiffelmann collection.)

Six

THE HOTELS

AND COTTAGES

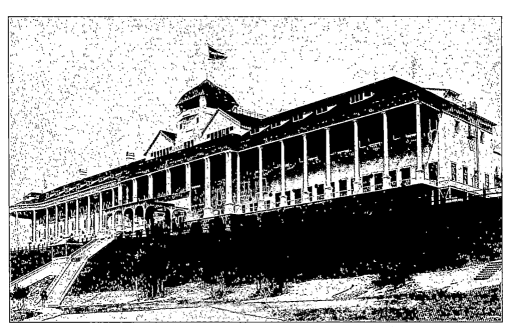

This image was taken in 1887 after the Colonial Revival–style Plank's Grand Hotel was completed. The name of John Plank, its first manager, was soon dropped from the name of Mackinac Island's most prominent structure. Rates started at $3 per night. "The Grand," built with white pine on West Bluff by three railroad companies to promote business, has grown to include almost 400 guestrooms. (Courtesy of Petosky.)

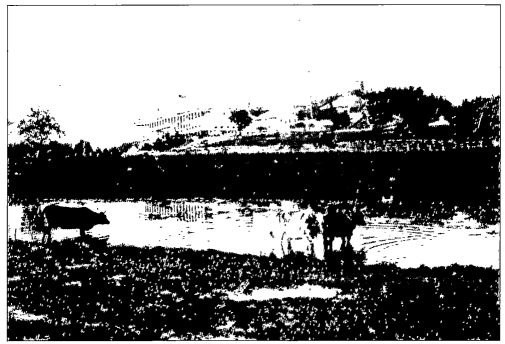

The village cow pasture extended west from Trinity Church, reaching a watering pond below the Grand Hotel, as shown about 1890. Cattle often escaped the pasture to wander the streets, leading to a "cow control" ordinance and impoundment. The Grand later leased this end of the pasture for a nine-hole golf course, and the pond became a water hazard. (Courtesy of Archives of Michigan.)

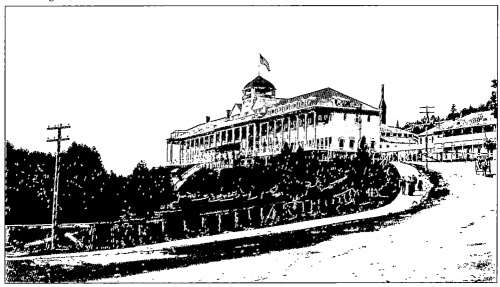

This shows a view of the Grand in 1900, taken from the dirt road leading from town named Cadotte Avenue. Improvements by that time included the west wing added in 1897, the smokestack, and the boardwalk along the road. In 1933, the hotel was purchased by former desk clerk William Stewart Woodfill. In 1979, it was sold to relatives, the Musser family, who have operated it and added two more wings since. (Courtesy of LOC, number 4a03674u.)

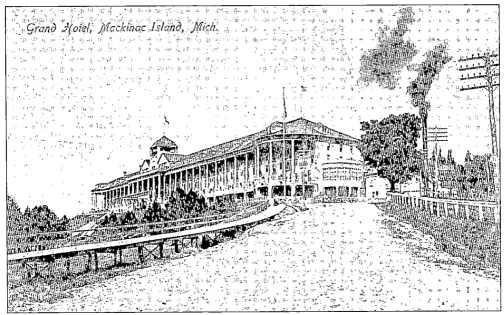

These images of the Grand from prior to 1920 show more substantial additions made to the building and grounds. Most significantly, the east end of the hotel had already been expanded in 1912 and given the same rounded appearance as the west end; a veranda was also added. For a time, the boardwalk along the avenue leading to the hotel was raised and led to a gate through an elaborate stone wall that was later removed. Further improvements to the roads and walkways can be seen, as well as poles and wires for electrical service that were added in 1913. Some of the buildings behind the hotel housed employees. The Grand Hotel has remained the largest summer-resort hotel in the world and its porch the longest at 627 feet. It is on the National Register of Historic Places. (Courtesy of Madelyn Le Page.)

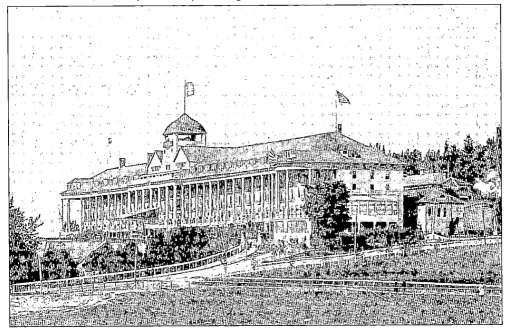

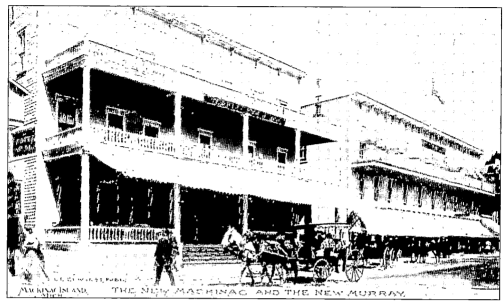

The New Mackinac Hotel and the New Murray Hotel were built side by side in 1887 and 1920, respectively. The original Mackinac House, constructed prior to 1860, burned down in 1887. The original Murray Hotel, built by settler Patrick Murray, was constructed in 1882. While the renovated Murray continues to operate to this day, the New Mackinac was demolished by the city in 1939. (Courtesy of Madelyn Le Page.)

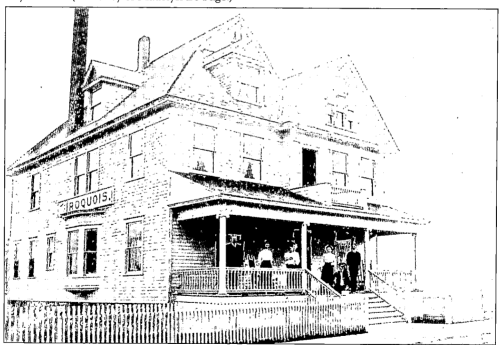

Between 1902 and 1904, the Benjamin family built a house on Windermere Point at the west end of downtown. It was sold soon after to Samuel Poole, who had been the park superintendent, and he opened it as the Iroquois Hotel (named after a Chicago hotel). (Courtesy of Bentley, Poole folder 15.)

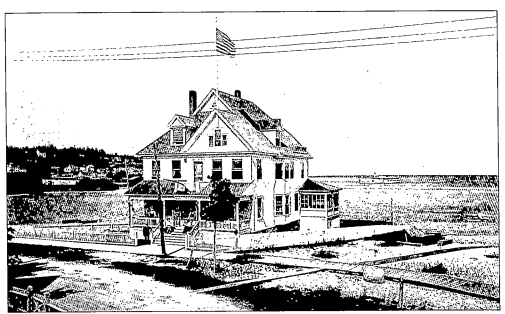

Beginning in 1907, the Iroquois on the Beach was enlarged and renovated in stages, as seen in these photographs. Above, the location of the hotel is more clearly defined, with the harbor behind it to the east. In 1954, Sarah Alicia Poole sold the Iroquois to the McIntire family, which has continued to own and operate it seasonally, along with its Carriage House Restaurant, which looks out at Round Island Passage. Sarah A. Poole either took, collected—or both—many of the images in this book. Her family was among the founders of Little Stone Church. (Courtesy of Margaret McIntire, proprietress, Hotel Iroquois on the Beach.)

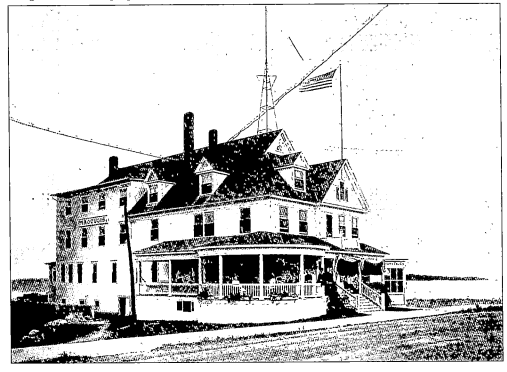

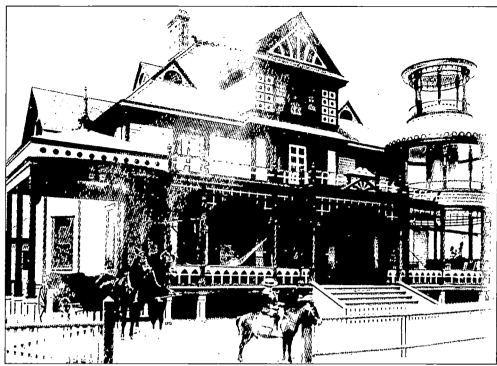

In 1887, the Anthony family summer residence was constructed across Main Street from Windermere Point. As shown in this tower, a widow's walk allowed island wives to look for their husbands' ships and boats returning from fishing or other occasionally dangerous work on the Great Lakes. After this photograph was taken, the house was renovated into the Windermere Hotel and the widow's walk replaced by a sunroom in 1904. (Courtesy of Doud.)

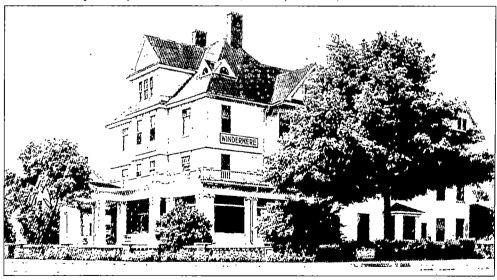

Since purchased and opened in 1904 by Patrick Doud, the Windermere has remained mostly unchanged in appearance. The hotel continues to be owned and operated by the Doud family. The Windermere has only been open for the warmer months of the year, which has also generally been true of the island's larger hotels and resorts. (Courtesy of Madelyn Le Page.)

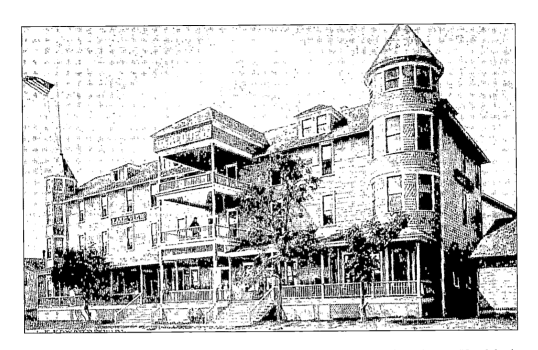

These detailed sketches from early postcards (below dated 1907) depict the Lakeview Hotel, built in 1858 by Reuben Chapman in the west end of the City of Mackinac Island's business district, across Main Street from the harbor. It was later operated by the Cable family, who added its two large wings. Its rooms cost about $3 a night in 1900, the going rate at the time among island hotels. This large hotel has also housed a number of restaurants, shops, and taverns, as well as an indoor swimming pool. Until recent renovations were done, the Lakeview hosted a State of Michigan historical marker. (Above, courtesy of Madelyn Le Page; below, courtesy of Petosky.)

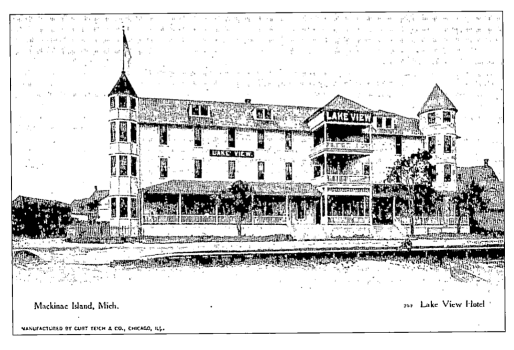

Mackinac Island, Mich. 255 Lake View Hotel

MANUFACTURED BY CURT TEICH & CO., CHICAGO, ILL.

83

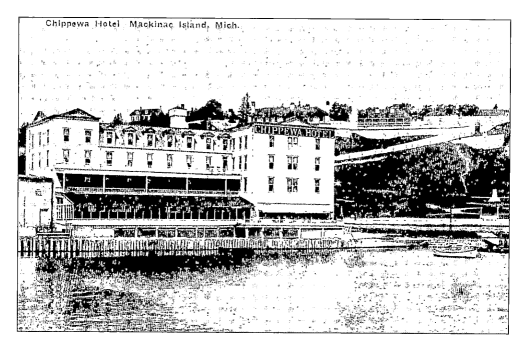

Marking the east end of the City of Mackinac Island's downtown business district, the Chippewa Hotel was erected in 1902 on the shoreline of the harbor near Union Terminal Pier. It was originally run by the George Arnold family. Also containing a restaurant, small shops, and the famous Pink Pony Bar (complete with pink furniture) for much of its history, the Chippewa enjoys a location close to the island's marina that has endeared it to the sailing and boating public. The hotel has for several decades been owned by the Benser family, as have been a number of other businesses on the island. (Courtesy of Madelyn Le Page.)

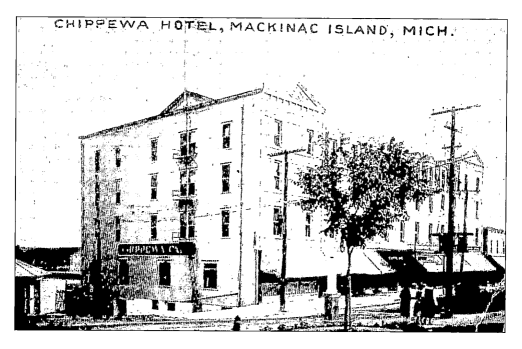

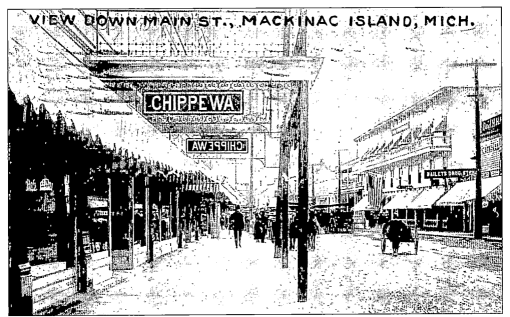

A postcard view of the front of the Chippewa Hotel, taken from Main Street in the early 1900s, gives an idea of the busy downtown activity that goes on daily just outside the hotel doors. Most of the island's large hotels and resorts have been located outside or at the edge of the city, where there has been somewhat less traffic but also less proximity to other businesses. (Courtesy of Madelyn Le Page.)

Chateau Beaumont (left) and La Chance Cottage (right), shown early in the 20th century, are representative of smaller Mackinac Island hotels and, later, bed and breakfasts that have utilized the same Victorian architecture and charm as their larger competitors. Both hotels have since been renovated and renamed. Their views to and from the east harbor area have since been somewhat obscured by development of residences along the shoreline. (Courtesy of Madelyn Le Page.)

The large and majestic Island House Hotel was built in 1852 by settler Charles O'Malley on the beach of the harbor and was moved after 1865 across Huron Street. The west and east wings were added to the original building in 1895 and 1912, respectively. It is the island's oldest operating hotel. (Courtesy of LOC, number 4a07879u.)

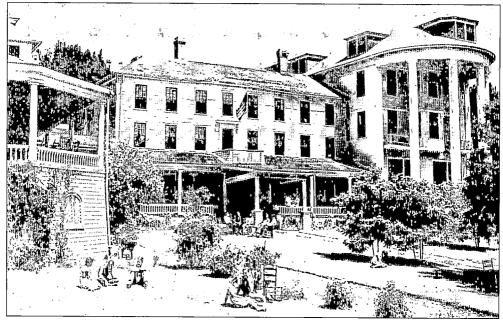

This later view of the Island House from a different angle captures the east end of the building with its third story, pillars, and large picture windows overlooking the water. A restaurant has been on the first floor of that wing of the hotel for many years. In 1970, floors and rooms were added around the hallway that connected the west wing to the rest of the hotel. (Courtesy of Madelyn Le Page.)

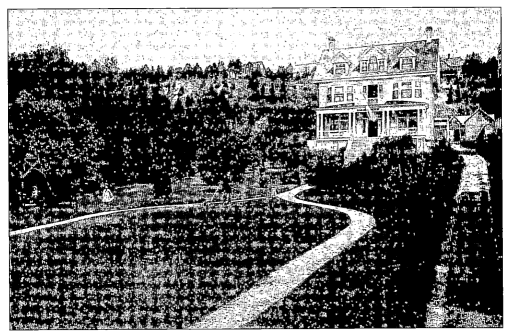

Also across Huron Street from the east harbor, St. Cloud was another of the smaller Mackinac Island hotels in the early 20th century. Rebuilt after a 1900 fire, it was operated by Helen Pfeiffelmann, who offered rooms with running water, steam heat, and maid service for $3 a night. The building was later converted for use as employee housing. (Courtesy of Tom Pfeiffelmann collection.)

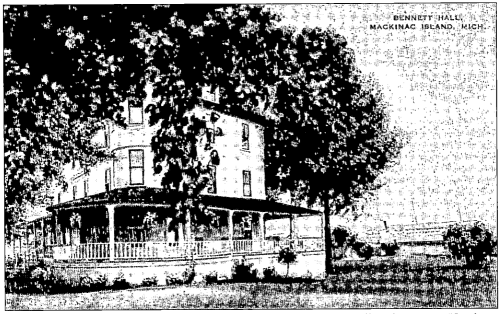

Another smaller, early-1900s Mackinac Island lodge was Bennett Hall and Cottages Hotel, set along the east harbor and owned by Walter Hill. This is one of many old hotels that are no longer open. On the other hand, new hotels and bed-and-breakfasts have continued to periodically be built. Even if not historical, due to building codes and designs consistent with the island's theme, they appear to be. (Courtesy of Tom Pfeiffelmann collection.)

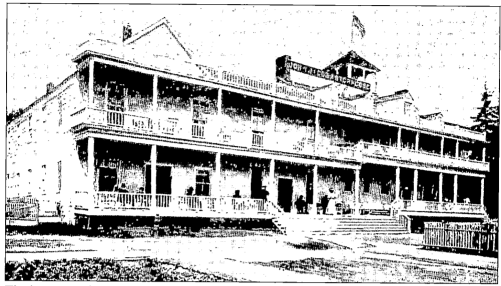

The largest Mackinac Island hotel no longer used as such is the Astor House on Market Street. When built beginning in 1810, the structure was the world headquarters for the American Fur Company. It was founded by John Jacob Astor in 1796 as America's first corporation, and it employed thousands of people when in its prime. By 1820, Mackinac Island controlled 95 percent of the northwest fur trade. Until 1834, voyageurs brought thousands of furs (mostly beaver pelts) for sorting, recording, and shipping to places as far away as Europe. The building included a warehouse built in 1821 and quarters for the manager and clerks. From fur trading, Astor became the nation's first millionaire. The building, serving as a hotel, became McLeod House in the early 1860s and was renamed Astor House in 1870. (Above, courtesy of Madelyn Le Page; below, courtesy of Tom Pfeiffelmann collection.)

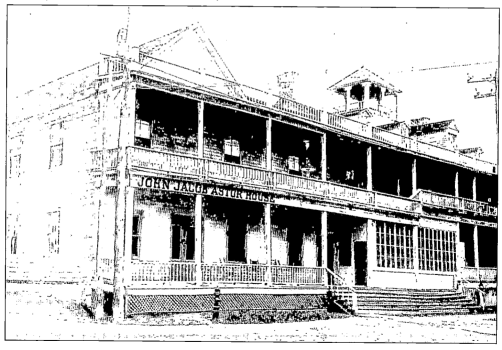

In 1901, Stonecliffe was constructed by Michael Cudahy, a wealthy Chicago meatpacker, near the top of the bluff, a couple of miles uphill from the City of Mackinac Island looking to the west toward St. Ignace. Unlike most of the Victorian architecture on the island, this tastefully decorated lodge was built in the Tudor style. Over the decades, numerous buildings were added to its 150-acre grounds, making a resort that included additional lodging and a separate restaurant (complete with a historic single-lane bowling alley). Construction of a golf course began, but it was purchased, along with the restaurant, by the Grand Hotel. Among lodging places that have continued to operate on the island, Stonecliffe has been the most remote from the city, escaping its hustle and bustle but requiring a longer walk or ride.

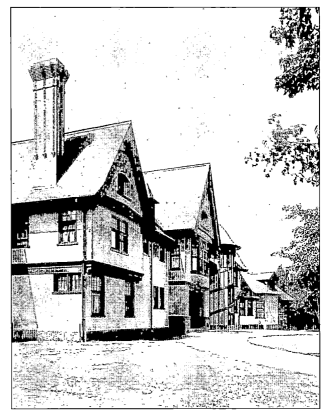

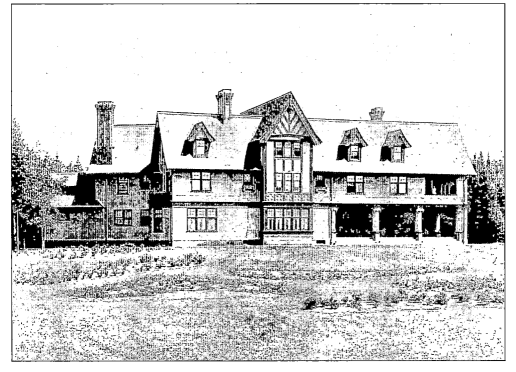

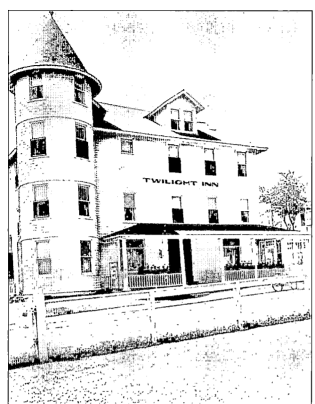

The Twilight Inn (shown here) and the Windsor Hotel next door (formerly the Grand Central) were small hotels immediately behind the Lakeview Hotel on Hoban Street. Neither continued in operation as lodgings but have long since been owned and utilized as seasonal housing for some of Grand Hotel's hundreds of employees. (Courtesy of Tom Pfeiffelmann collection.)

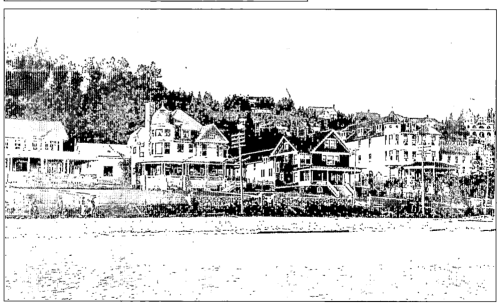

As hotel construction on Mackinac Island began to blossom in the mid-1880s, the majestic mansions of summer residents, known as "cottages," also began to appear. This 1898 image shows three such homes (to the left), situated behind the east harbor and between downtown and Mission Point. Many more were constructed in this vicinity and also just west of Windermere Point, most before around 1905. (Courtesy of Clarke, Trelfa.)

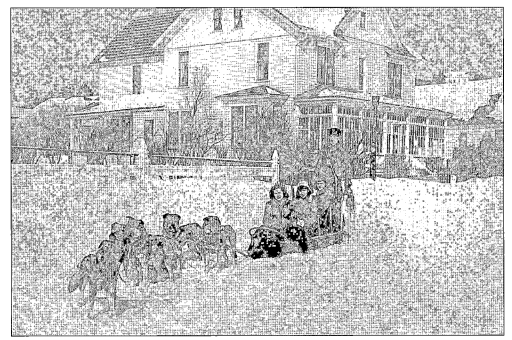

The home pictured behind the dogsled is the McNally cottage, located on Main Street near the west end of downtown. Originally a private residence, it was later operated as a tourist home. At the time of publication, the demolition of this original historical house was being planned by its current owner, a sign of an ever-changing downtown commercial district. (Courtesy of Tom Pfeiffelmann collection.)

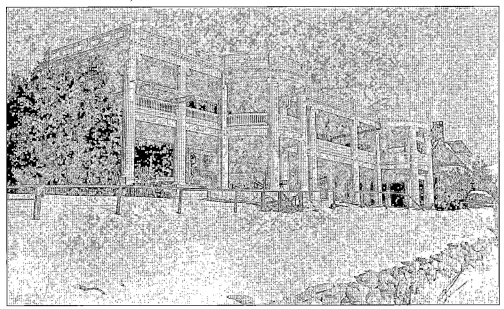

Many of the largest and most striking Mackinac Island seasonal cottages were built upon the West and East Bluffs. The East Bluff cottages, such as the Neoclassical Revival Bowen house, shown in the early 1900s, command phenomenal views of the Round Island Passage, Bois Blanc Island, and Mission Point below. (Courtesy of Mackinac Island Library.)

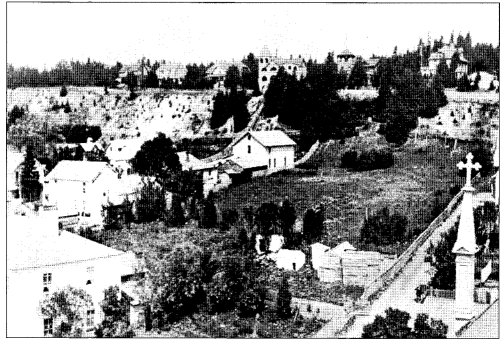

This undated but early image of cottages constructed on part of the East Bluff appears to have been taken from an upper level, or even the roof, of St. Anne's Church after it was rebuilt east of the downtown. It gives a good sense of the height of East Bluff. Many additional homes were later added on the streets around the church below the bluff. (Courtesy of Tom Pfeiffelman Collection.)

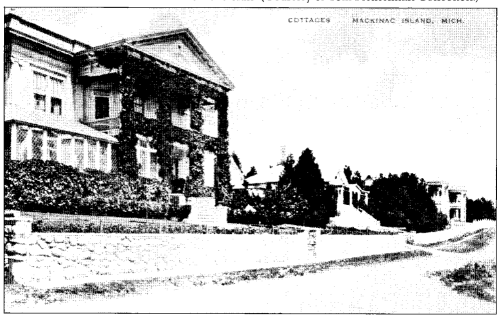

This old postcard provides a closer view of a few East Bluff cottages. The road forks at this location, one route leading downhill to Mission Point and the other to a dead end at the Robinson's Folly end of the bluff. The East Bluff cottages were constructed between 1895 and 1900. Also on East Bluff are the Anne's Tablet and Lewis Cass monuments. (Courtesy of Armand "Smi" Horn.)

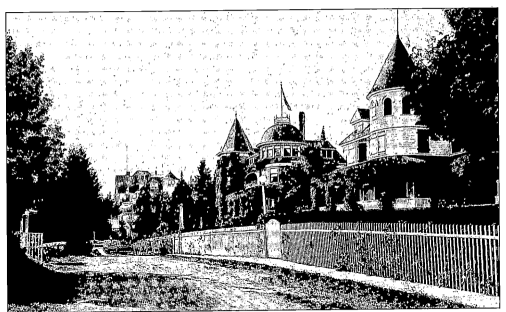

From 1886 to 1891, a large number of West Bluff summer homes were built overlooking the Straits. They are among the largest residences on the island. The homeowners have leased the land on a long-term basis from Michigan's state parks. Hubbard's Annex, extending from the bluff into the woods, contains additional cottages on private land. This image was taken prior to 1923. (Courtesy of Archives of Michigan and LOC.)

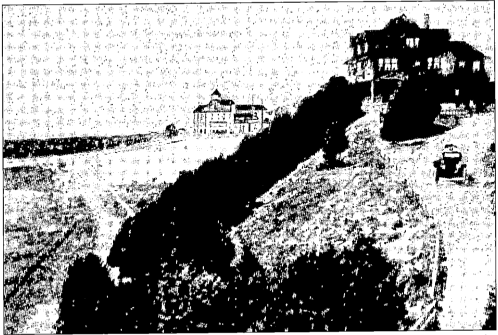

The Young family cottage, built west of Fort Mackinac between 1901 and 1902, later became the governor's summer residence. The vehicle heading down Fort Hill may have been painted onto this postcard. If the motorcar is actual, the image is either pinpointed to a date in 1901 prior to that year's state park ban on automobiles, or the driver was violating that ban. (Courtesy of Pat Andress.)

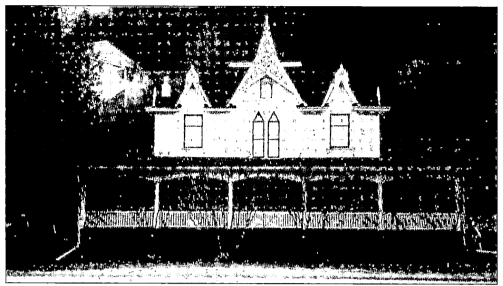

Built in 1882, the Sheeley family house was moved in the 1950s by horses to its present location, which is further east, on Mission Point. Although the photograph was taken about 100 years after its construction, the home's unique Gothic Revival architecture has remained basically unchanged. Registered as a historic site, the house has been operated as the Small Point Bed and Breakfast for the past few decades. (Courtesy of Sally North.)

It was not only the exteriors of island hotels and cottages that were designed with creativity. Each unique, the structures have interiors that range from rustic to glamorous, but they have been consistently well constructed with quality materials and have been well maintained. As an example, this small lobby in the Grand Hotel, once appointed the Blue Room, led to the hotel's theater/ballroom. The Grand has doubled in size since it was constructed. (Courtesy of Madelyn Le Page.)

Seven

GETTING TO, FROM, AND AROUND THE ISLAND

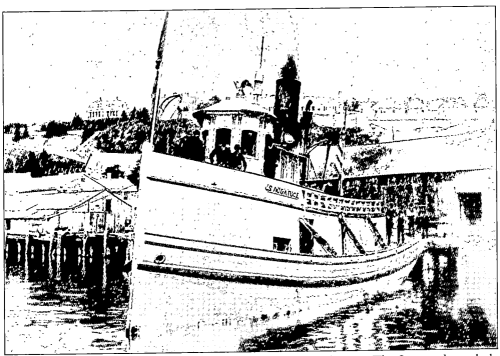

Transportation has played a major role in Mackinac Island's history. The *Saugatuck* regularly hauled lumber and mail between small ports on northern Lake Huron, including Mackinac Island. Islanders lacking transportation to the mainland began offering to purchase rides on the *Saugatuck* to St. Ignace or Mackinaw City. The owner eventually relented, some years before this 1880 photograph was taken, making *Saugatuck* the first Mackinac Island ferryboat. (Courtesy of Tom Pfeiffelmann collection.)

The primary mode of transportation to and from Mackinac Island over the centuries has been the boat, except when winter ice has made this impossible. From the birch bark canoes of the Native Americans and missionaries to sailboats and motorized craft, boats have always been the lifeline of Mackinac Island, transporting people, animals, and goods. (Courtesy of Tom Pfeiffelmann collection.)

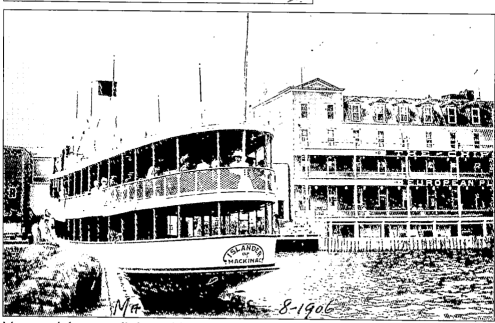

More people have travelled to and from Mackinac Island by passenger ferryboat service out of St. Ignace and Mackinaw City than by any other means. A number of ferry companies and dozens of individual ferryboats have served the island over the past 100-plus years. Illustrative of those ferries was the original *Islander of Mackinac*, shown in 1906 at Union Terminal Pier. (Courtesy of Mackinac Island Library.)

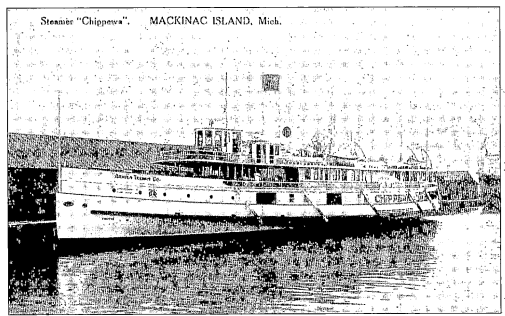

The Arnold Transit Company's 200-foot steel ferry *Chippewa*, built in 1900, ran between Mackinac and Sault Ste. Marie. The Arnold Line has served the island, primarily from St. Ignace and Mackinaw City, since 1878. Current service is also provided by Star Line and Shepler's. Winter ice has suspended ferry operations all but one unusually mild winter. Typically, ferries run daily from mid-April to early January. (Courtesy of Madelyn Le Page.)

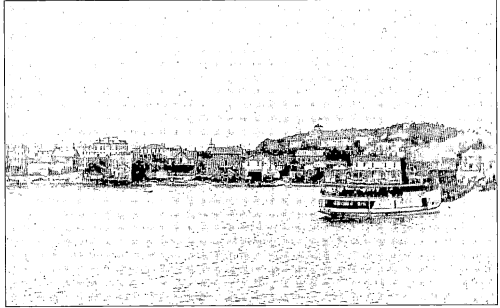

A passenger ferryboat approaches a Mackinac Island dock in July 1907; the Grand Hotel and city can be seen in the background. Each ferryboat company has generally maintained its own dock in the harbor. During the winter ice months, transportation has been accomplished either by crossing the ice (if sufficiently solid) or by flying to the island's airport, which has a 3,500-foot paved runway located on the bluff facing St. Ignace. (Courtesy of Clarke, Trelfa.)

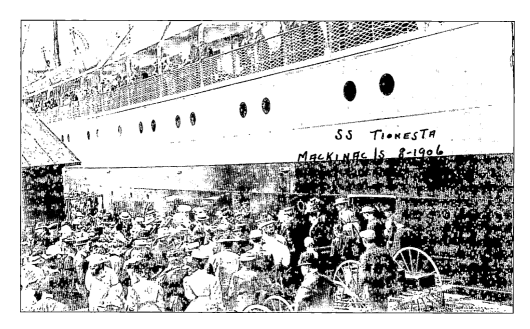

SS TIONESTA
MACKINAC IS 8-1906

Beginning in the late 19th century, the emergence of Mackinac Island as a tourist destination brought large passenger steamships from ports such as Chicago and Detroit. The SS *Tionesta* (above) and SS *Georgia* (below), both shown in 1906, were among the ships that regularly called at the island. Some transported passengers to and from the island and other Great Lakes ports, and others were self-contained cruises with passengers making day excursions on the island while their ships were at dock. The Anchor Line sister ships—*Tionesta, Juniata,* and *Octorara,* in particular—compared in luxury with Mackinac Island's largest hotels. They included ornate mahogany, gold dining rooms, and luxurious cabins. The *Juniata*, built in 1904, was partially rebuilt in 1941 and renamed the *Milwaukee Clipper,* which operated as a Lake Michigan car ferry until retired as a ship museum in Muskegon, Michigan. (Courtesy of Mackinac Island Library.)

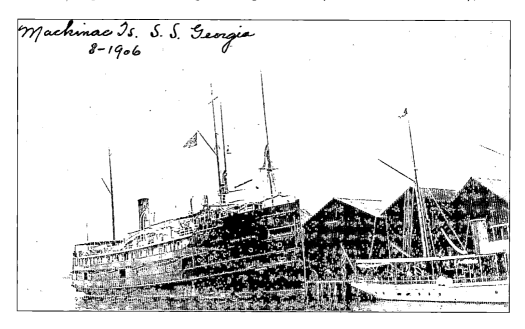

Mackinac Is. S. S. Georgia
8-1906

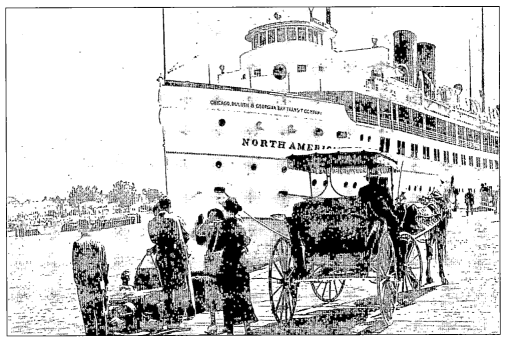

The *North American*, shown around 1905, was among the last of the large Great Lakes cruise ships. This industry temporarily died out in the 1960s. However, a resurgence of Great Lakes cruises began within 30 years, with smaller and more modern ships carrying fewer passengers. Ships and boats putting in at Union Terminal Pier have been met by horse-drawn carriages for years. (Courtesy of Tom Pfeiffelmann collection.)

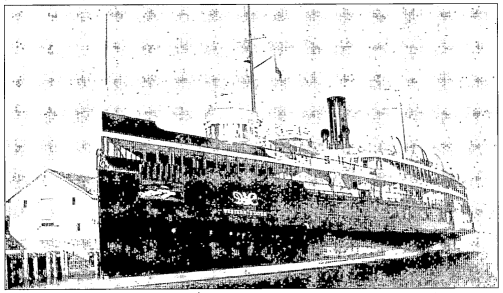

The *Western States* and its sister ship *Eastern States* of the Detroit and Cleveland Navigation Company ran passengers between Detroit and Chicago from 1904 until the beginning of World War II. Launched in 1902 with a 350-foot steel hull, *Western States* became a floating hotel in Tawas City in the 1950s until it burned. The first steamboat to stop at Mackinac Island was the *Walk-in-the-Water*, in 1819, on its maiden voyage. (Courtesy of Tom Pfeiffelmann collection.)

The Georgian Bay Line's sister ships, the *North American* and *South American*, were launched in 1913 and 1914, respectively, and regularly stopped at Mackinac through the mid-20th century. They were each 260 feet in length. The line advertised Mackinac Island as the "Bermuda of the North." Above, some of the incongruities of Mackinac Island transportation are highlighted by the *North American* at dock behind a Grand Hotel courtesy coach and some horseback riders. Below, the *South American* approaches Union Terminal Pier. It was the last large Great Lakes cruise ship of that era to put in at the island during a farewell visit in 1967. As a child, the author had the privilege of viewing this ship up close from a boat in the harbor, as passengers peered over the deck rails far above the water. (Courtesy of Tom Pfeiffelmann collection.)

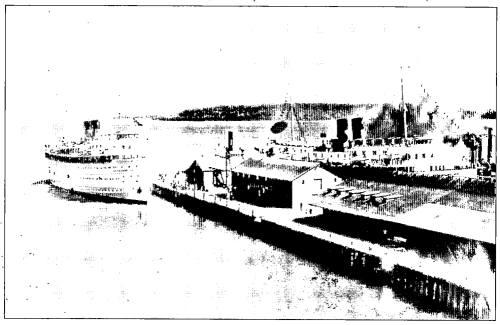

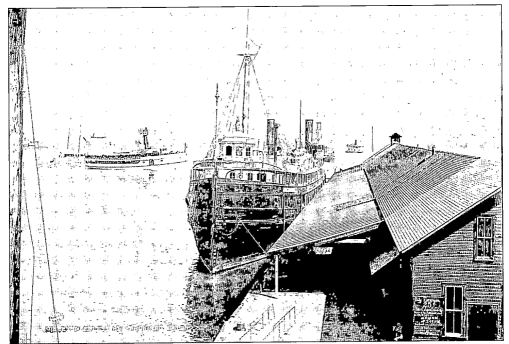

The 211-foot passenger cruiser *Peerless* was photographed at Union Terminal Pier in front of the *Chippewa*, with the *Straits Islander* visible to the left. Built in 1872 for the Lake Superior Line, the *Peerless* had its hull painted black in 1879. It ran tourists from Chicago to Duluth until 1906. It was renamed *Muskegon* in 1907 and abandoned after a 1910 fire. (Courtesy of LOC, number 4a07885u.)

Taken by a tourist after 1915, this overlook from Fort Mackinac includes the *Greater Detroit* at Union Terminal Pier. To protect the harbor from rough seas, the east and west breakwaters were built in 1913; the latter can be seen in the background. (Courtesy of Mackinac Island Library.)

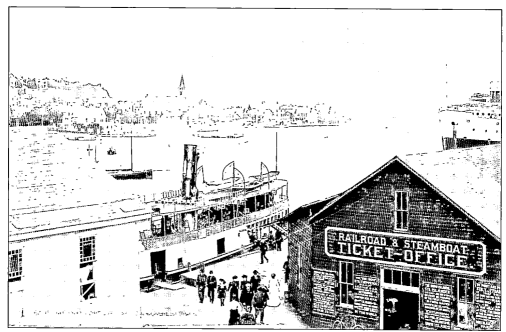

Boats require docks to load and unload passengers and freight, and they are essential to Mackinac Island. Union Terminal Pier has been the biggest workhorse of island docks, capable of handling large ships and horse-drawn wagons. Despite the sign on the ticket office, there has never been a railroad on the island. (Courtesy of LOC.)

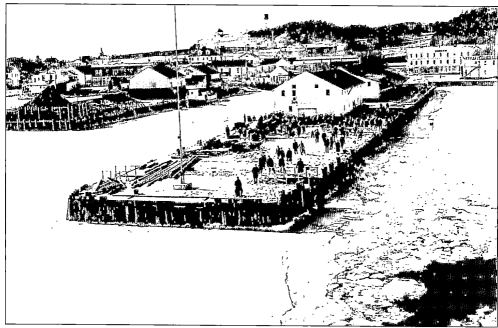

From the upper deck of a ferryboat in the mid-1900s, Union Terminal Pier is shown surrounded by ice. While no icebreaker ships serve the island, the thick steel hulls of ferryboats of the Arnold Line enable them to navigate through floating or thin ice for parts of most winters, at least until the ice has become too thick or firm to move through. (Courtesy of Tom Pfeiffelmann collection.)

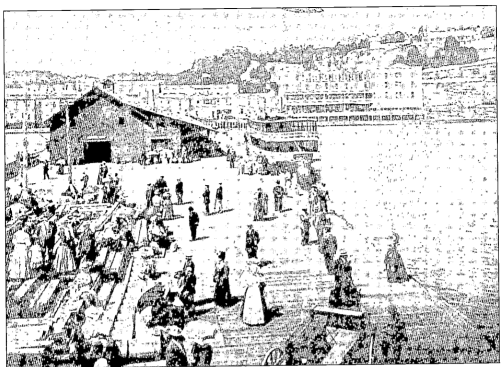

An early-20th-century image depicts crowds waiting for ships or ferries on Union Terminal Pier. Stacks of building materials and other freight provide impromptu seating. This photograph also illustrates the fairly formal attire worn on a daily basis in that era. (Courtesy of Metivier Inn.)

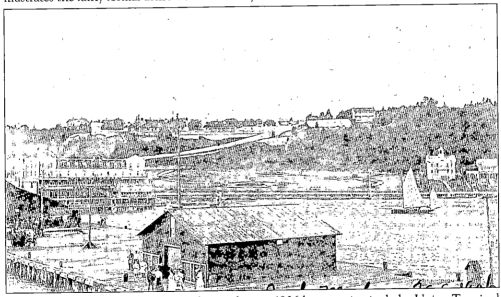

Another photograph from a ship or ferry, taken in 1906 by a tourist, includes Union Terminal Pier, the Chippewa Hotel, Marquette Park (prior to its dedication), Fort Mackinac, and the Indian Dormitory. Many of the docks (and the buildings on them) were constructed for the commercial fishing industry but later adapted for transportation usage. Some of these docks and buildings remain. (Courtesy of Mackinac Island Library.)

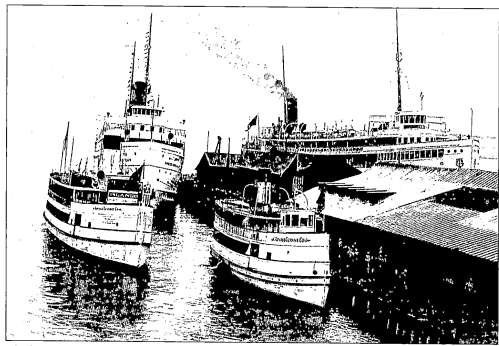

The heavy demands on Union Terminal Pier are emphasized in this early-1900s picture in which the pier is shown being utilized by two large steamships and two ferryboats. The harbor's size, its water depth, and shoreline development have combined to limit the docking facilities that could be constructed to handle the volumes of people and freight that arrive at Mackinac. (Courtesy of Tom Pfeiffelmann collection.)

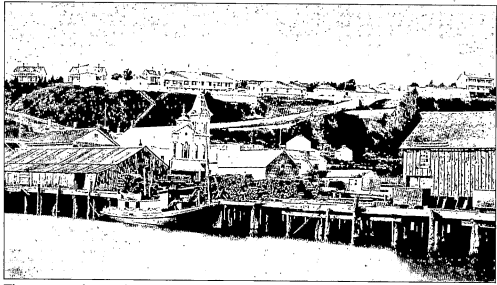

This stereograph was taken before 1895, when Mackinac Island was a national park, and depicts the relative disrepair of Union Terminal Pier prior to the arrival of regular ferry traffic. Note that the Chippewa Hotel has not yet been constructed. Prior to the ferry services from St. Ignace or Mackinaw City, regular passage was limited to larger ships, usually from distant cities. (Courtesy of Clarke, Main.)

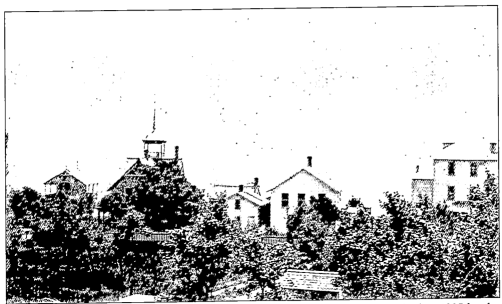

Viewed over Bennett Hall in 1906, the *Northland* departs the island. Launched in 1895 by the Northern Steamship Company, this 385-footer regularly carried 540 passengers between Buffalo and Duluth, stopping at Mackinac Island. The *Northland* and sister ship *North West* were the first passenger-only ships and were the most luxurious Great Lakes ships to date. So costly that full bookings yielded no profits, their operation promoted an affiliated railroad. (Courtesy of Mackinac Island Library.)

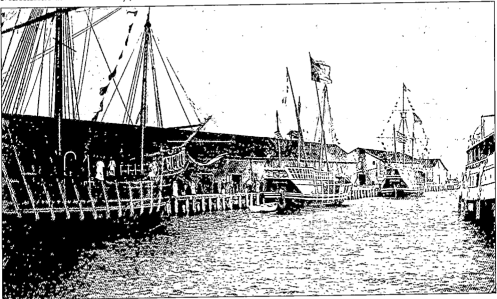

Replicas of the *Nina*, *Pinta*, and *Santa Maria* toured the Great Lakes and are shown visiting Mackinac Island in this picture believed to be from the 1920s. The island's uniqueness and location have made it a popular stop for all types of maritime craft. The Royal Yacht *Britannia* sailed slowly past with Queen Elizabeth II on board in 1959, and although not on a sightseeing trip, a German U-boat (the *U-505*) that was captured in the Atlantic by a force led by an officer with Mackinac ties docked at the island during a journey to Chicago after World War II.

Prior to construction of the island airport, ferry captains had to be aggressive in attempts to reach the island in winter. In this image, after the original Arnold Line ferry *Ottawa* became stuck in the ice, passengers had to disembark and walk to shore through windrowed ice formations. The boy in the foreground is a member of the island's Wellington family. (Courtesy of Bentley, Poole folder 17.)

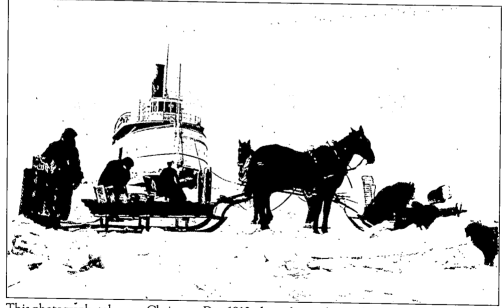

This photograph, taken on Christmas Day 1910, shows horse-drawn sleighs with passengers and luggage on the ice of Round Island Passage going to meet a ship leaving for the Saginaw Bay area of Michigan. The winter freeze came earlier than usual that year. (Courtesy of Mackinac Island Library.)

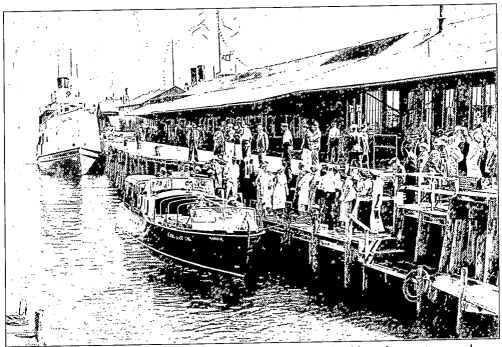

The greatest percentages of watercraft docking at Mackinac Island have been private yachts or pleasure boats rather than commercial vessels. Illustrative of those vessels is this beautiful wood 1930s cabin cruiser *Good News*, later commandeered for Navy use during World War II. (Courtesy of Tom Pfeiffelmann collection.)

Commercial ferries have conveyed more than people to Mackinac Island. A number of boats devoted exclusively to freight have been utilized over the years, some of them converted military landing craft (like this used in the MRA complex construction in the 1950s) or former car ferries. The island's reliance on horses has required that supplies such as hay, too, be ferried between the mainland and Mackinac.

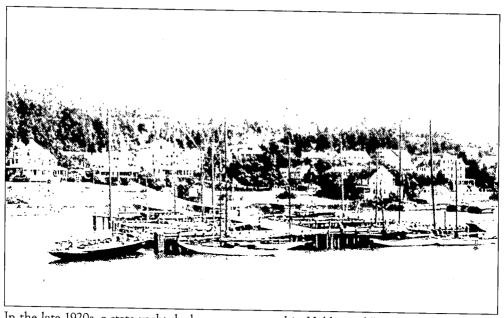

In the late 1920s, a state yacht dock was constructed in Haldimand Bay. Renovated in 1965 and in 1986, the marina has 76 boat slips and is operated during summer months only. At peak times, it has been full, leaving excess boats to "raft off" from one another or anchor in the harbor. During major sailboat races, close to 500 vessels have been in the harbor. (Courtesy of Tom Pfeiffelmann collection.)

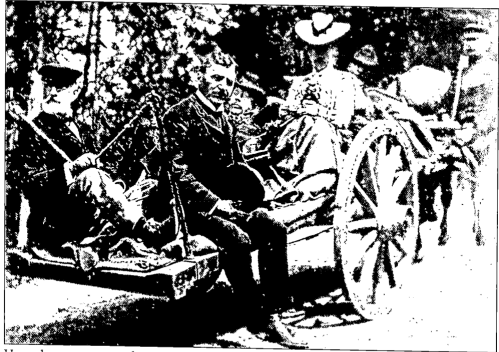

Horse-drawn wagon was the primary form of transportation almost everywhere in the 1860s, when this picture was taken. The unique transportation situation on the island began with the ban on private automobiles on July 6, 1898, and grew as autos became more common on the mainland.

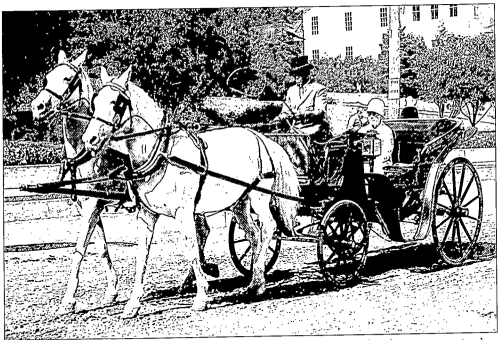

The horse-drawn transportation that has continued on Mackinac Island without interruption has included unique carriages and buggies of all types. They have ranged from fairly generic carriages that have served as taxicabs and freight drays to the courtesy coaches offered by certain hotels for guest transport to ornate private buggies. Vehicles are drawn by teams of two or more horses or by a single horse.

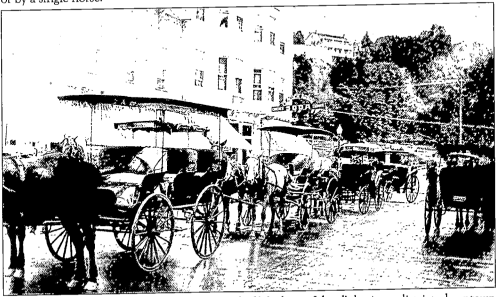

By the time of this 1922 image of the east end of Mackinac Island's business district, downtown horse-and-carriage traffic had become heavy in the daytime during peak summer months and has remained so since. "Drive yourself" rental carriages, drawn by a single horse, have been available to summer tourists since the late 1800s, but they have long been banned from Main Street to reduce congestion. (Courtesy of Clarke, Trelfa.)

Shown in 1952, one of the larger horse-drawn vehicles on Mackinac Island has been a Grand Hotel courtesy coach nicknamed "the Bus." Built by Fisher Body and still in use in 2011, this coach has provided transportation for several guests at a time, enclosed for protection from the weather. Professional carriage drivers of island businesses have been well trained and are adept at safely maneuvering in traffic that often includes pedestrians and bicyclists. (Courtesy of Petosky.)

A fancy Mackinac Island carriage of the past is shown here in the downtown district. Carriage traffic is permitted on all island roads except a few of the steeper bluffs. There are small public museums of old carriages at Surrey Hill and the Grand Hotel. Most of the island's hundreds of horses are stabled on the mainland in the winter, when only about 20 remain for island work. (Courtesy of Tom Pfeiffelmann collection.)

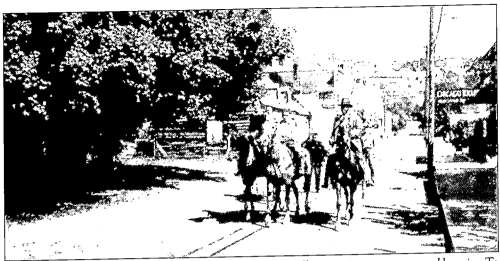

Mackinac Island horse transport has not been limited to pulling carriages, wagons, and buggies. To a lesser degree, horseback riding has also been common. Guided rides have been available to tourists for many years. This image from the 1930s depicts riders who have just left the Chicago Riding Stables, later Cindy's Stables, on Market Street. Several island homes and cottages have beautiful corrals and stables for privately owned horses. (Courtesy of Tom Pfeiffelmann collection.)

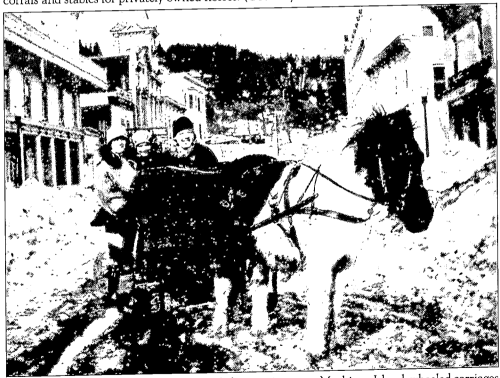

In the often snowy and harsh Northern Michigan winters on Mackinac Island, wheeled carriages sometimes do not work well. Horse-drawn sleighs have been used at times, adding a further romantic element and Norman Rockwell–style sentiment to the island's culture. This group of young girls frolics with a pony sleigh on a snow-covered Main Street in the early 1900s. (Courtesy of Tom Pfeiffelmann collection.)

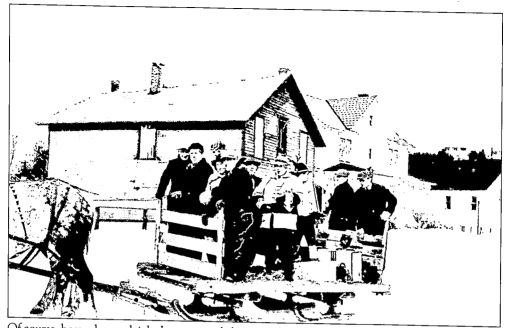

Of course, horse-drawn sleighs have not only been used by the children of Mackinac Island. Above, a group of adults enjoys a gliding party on one of the island streets. Notice the accordion player providing music for the adventure. Below, a number of horse-drawn sleighs on the harbor's ice show that sleighs frequently hauled lumber, hay, and other materials before motorized snowmobiles were invented in the early 1900s. This included hauls to and from St. Ignace when sufficient ice cover extended the entire distance, which was about six miles from the harbor. On much less frequent occasions, ice stretched all the way across the Straits to Mackinaw City, seven miles away. Unfortunately, there are accounts of horses sometimes going through the ice and not always being successfully pulled back out. Sleighs have also been used for travel on island roads. (Courtesy of Tom Pfeiffelmann collection.)

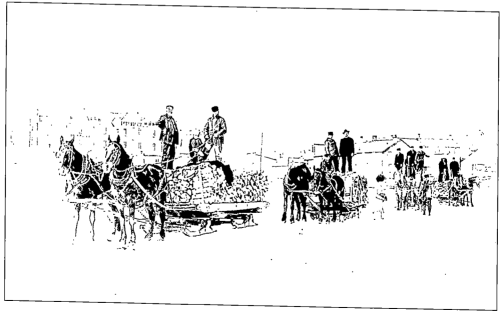

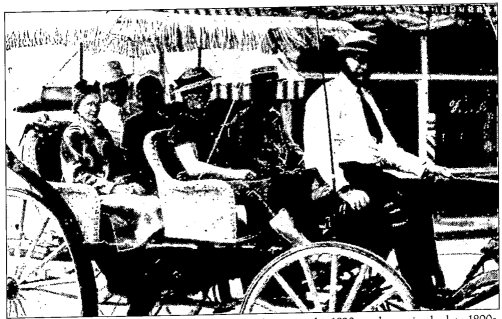

A seasonal driver-narrated carriage-tour industry began in the 1820s and grew in the late 1800s, catering to ships' passengers and tourists. Independent carriage drivers, such as William Donnelly—shown with passengers in 1935—competed fiercely for business. In 1948, the drivers united to form Carriage Tours, now the world's largest carriage-livery company (with 350 horses and 100 carriages) and the nation's oldest. Currently, two companies serve about 200,000 customers per summer. (Courtesy of Tom Pfeiffelmann collection.)

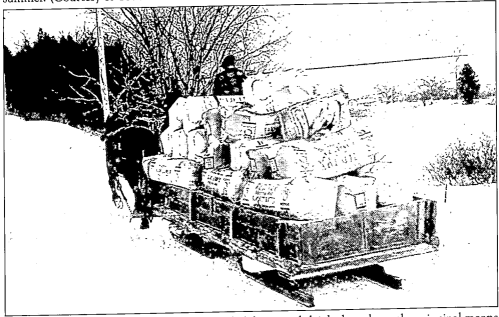

For over 100 years, horse-drawn wagons, called drays, and sleighs have been the principal means of hauling freight once on Mackinac Island. This sleigh is carrying materials for the construction of the MRA complex on Mission Point in the 1950s. Some drays have been flatbeds; others have had high sides enclosing their cargoes. Hackney and Percheron horses are primarily used.

Lady bicyclists in 1895 pause for a photograph and a rest from their sport, relatively new at the time, at the lakeshore below Robinson's Folly. This picture was taken by William Gardiner, who owned a turn-of-the-century studio in Fenton Hall after its opera house closed. His thousands of images include many of the highest quality and most striking poses ever shot on Mackinac Island. (Courtesy of Mackinac State Historic Parks.)

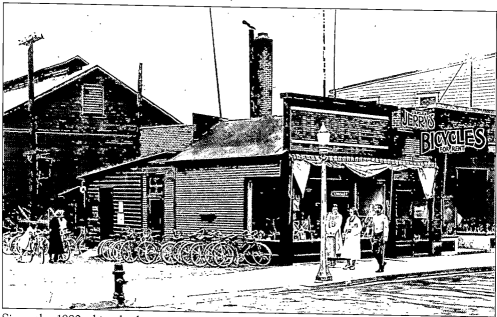

Since the 1880s, bicycles have increasingly provided an economical, easy, and healthy way to travel on Mackinac Island's narrow roads and streets. By the mid-20th century, bikes began to outnumber horses. Establishments, such as Jerry's in 1935, have continued to affordably rent bicycles. Beautiful and sometimes challenging bike and horse paths and trails were also developed. (Courtesy of Tom Pfeiffelmann collection.)

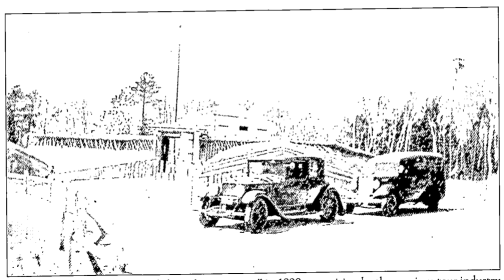

The municipal council banned "horseless carriages" in 1898 on petition by the carriage tour industry and the public. After continued carriage accidents outside city limits when horses were frightened by Earl Anthony's steam-powered Locomobile, state park officials prohibited cars from the rest of the island's public roads in 1901. The bans were violated by some. E.M. Tellefson regularly drove his cars, including a 1928 Buick, and parked at Fort Holmes, where he maintained a radio tower for the shipping industry. The image above was taken about 1935. Tellefson was taken to court, and the Michigan Supreme Court eventually affirmed the bans. There have also been creative, unique forms of transportation that did not break the law but did raise eyebrows, as evidenced by the 1950s photograph below of an amphibious car landing on a small private shore of the harbor. (Above, courtesy of the Tom Pfeiffelmann collection.)

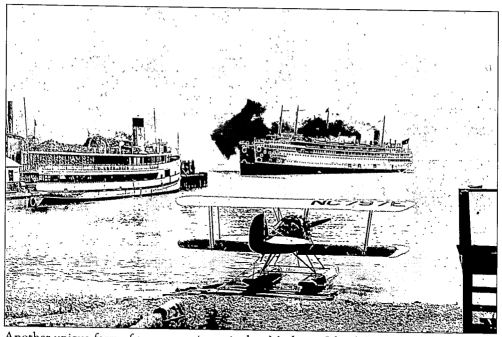

Another unique form of transportation suited to Mackinac Island, but rarely seen in recent years, was the seaplane. They were not uncommon in the island's harbor in the mid-1900s, and it is believed that both seaplanes shown were kept by island residents. The harbor provided calm water for takeoffs and landings, although they could undoubtedly be accomplished only when boat traffic was minimal. The above image depicts a variety of seagoing vessels that could be seen in the harbor. The seaplane pictured below was most likely a homemade model. Use of these planes would have been more convenient and faster than traveling by foot, horse, or bicycle to the airport, which was a couple of miles uphill from the city. (Below, courtesy of the Tom Pfeiffelmann collection.)

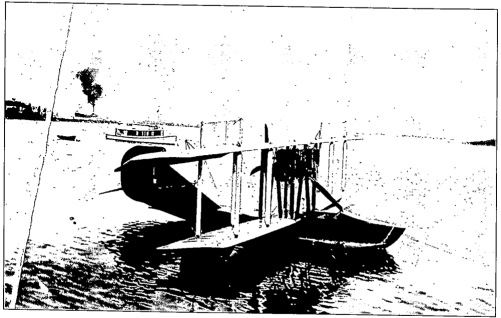

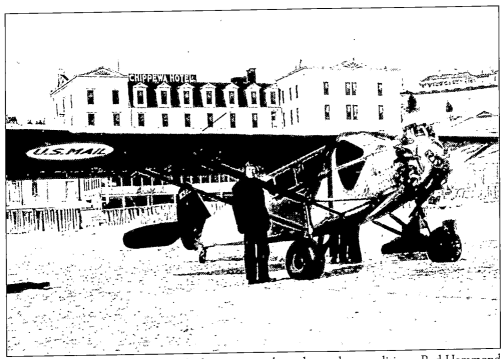

Living up to the post office's creed of continuing through weather conditions, Bud Hammond delivered the island's mail by plane, landing on the ice in the harbor. He dropped off letters to some homes in the city on foot, but undoubtedly left most mail at the post office. This form of postal service was provided through at least 1960. (Courtesy of Tom Pfeiffelmann collection.)

Here, horse-drawn sleighs are hauling lumber to Mackinac Island from Bois Blanc Island for use by residents in the early 20th century. The larger, heavily wooded Bois Blanc Island is beyond Round Island, a few miles to the southeast of Mackinac. All three islands are part of the Upper Peninsula's Mackinac County. (Courtesy of Armand "Smi" Horn.)

Homeward Bound, Bois Blanc; Mackinac Island, Mich.

The unidentified men in this 1890 photograph (on a postcard sent in 1916) also were hauling lumber from Bois Blanc Island to their Mackinac Island homes, this time by dogsled. With a population of less than 100 and few businesses, Bois Blanc and its abundant resources provided well for the people of Mackinac. (Courtesy of Bentley, Postcard box 7.)

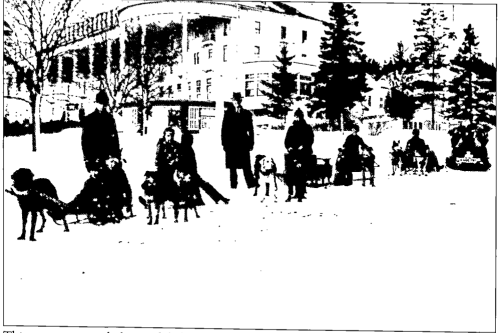

This group poses with dogs and sleds in front of the Grand Hotel, on the Cadotte Avenue hill, for this early- to mid-1900s shot. Dogsleds were another form of transportation that was somewhat common at one time (more for recreation than for actually getting places), but they have become very rare on the island in recent decades. (Courtesy of Tom Pfeiffelmann collection.)

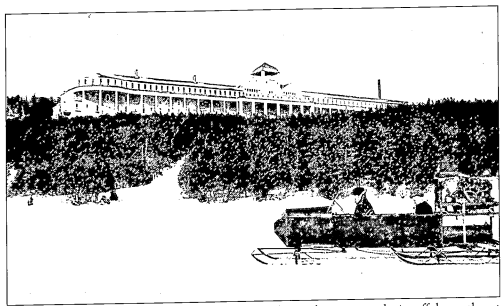

Air sleds were predecessors to snowmobiles. The sled shown above was on the ice off the southwest shore of Mackinac Island, with the Grand Hotel and Lakeshore Boulevard in the background. Below, an air sled from the 1950s MRA construction site is shown. Use of air sleds and snowmobiles was initially limited to crossing the ice bridge to and from St. Ignace in midwinter, and they were parked on island shores. Island and St. Ignace residents have piled their discarded Christmas trees on the shorelines in January for use in marking the safest trail across the ice. Ice bridges can last up to three months, but typically from late January until early March. The danger of ice crossing varies with weather, and there have been occasional tragic fatalities. In 1968, an exception was made to the motorized-vehicle ban to permit snowmobiles on most island roads. The ban had been ignored by many snowmobile riders for several years. (Above, courtesy of Bentley, McIntire Winter Views folder.)

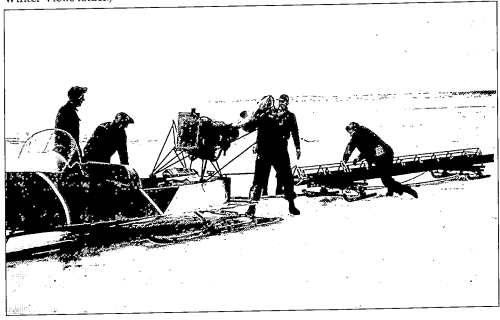

Depicted is a "Mackinaw Boat" of the 19th century. They were used for many purposes, including commercial fishing, which replaced fur trading as the primary industry in the 1830s. Trout, whitefish, pickerel, and cisco were processed and warehoused on the island before being shipped. Mackinac Island was the principal fishing center of upper Lakes Huron and Michigan until fish populations declined from overfishing and railroads benefitted mainland fishing ports. (Courtesy of Bentley, Poole folder 11.)

These women are just horsing around on this water wagon, but it was used for serious work—street cleaning. Everything that cannot be carried by people on Mackinac Island is hauled by horse-drawn vehicles, snowmobiles pulling sleds, commercial trucks (only by city permit), or in recent decades, tourists' luggage balanced in bicycle baskets by hotel "dock porters." (Courtesy of Tom Pfeiffelmann collection.)

Eight

TOURISM AND RECREATION

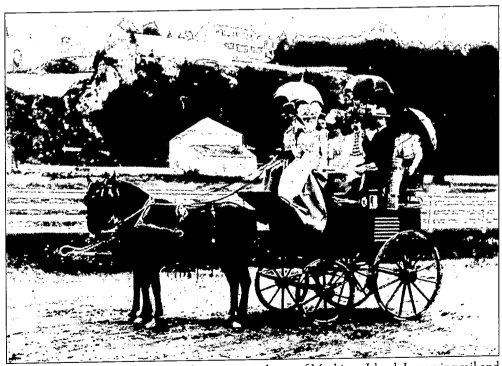

In the late 1800s, tourism became the primary industry of Mackinac Island. Improving rail and lake transportation permitted visitors to experience the island's splendor, escaping summer heat and hay fever. With their fine clothes and parasols, family and friends of Potter Palmer, a Chicago lumber baron, are pictured enjoying a beautiful carriage ride along Huron Street in front of Fort Mackinac and the Army farm around 1895. (Courtesy of Tom Pfeiffelmann collection.)

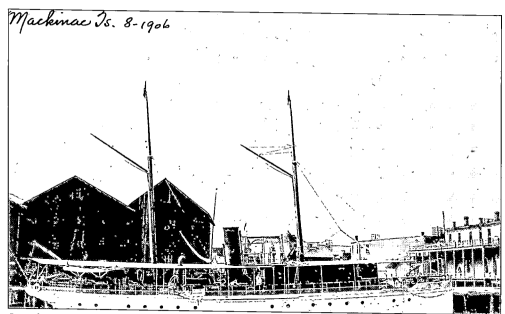

Significant numbers of island visitors have arrived not by commercial transportation, but by their own private boats. This 1906 sailing yacht is representative of many magnificent ships that have stopped to dock or anchor at the island, either briefly while cruising the Great Lakes or for an extended vacation. (Courtesy of Mackinac Island Library.)

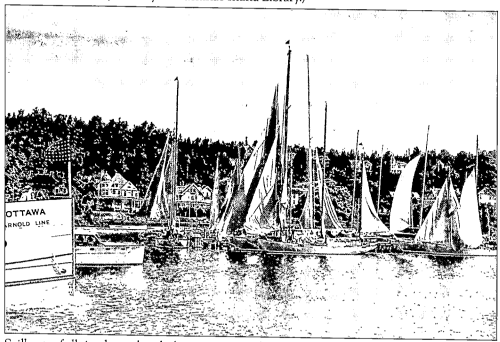

Sailboats of all sizes have played a large part in Mackinac Island culture. These mid-1900s sailboats are pictured at the island's marina. Whether part of a Great Lakes cruise or a short sail around the harbor, sailing enthusiasts are drawn by the relaxation and outdoor nature of the activity. There can been no better place or destination for a summer sail than Mackinac. (Courtesy of Tom Pfeiffelmann collection.)

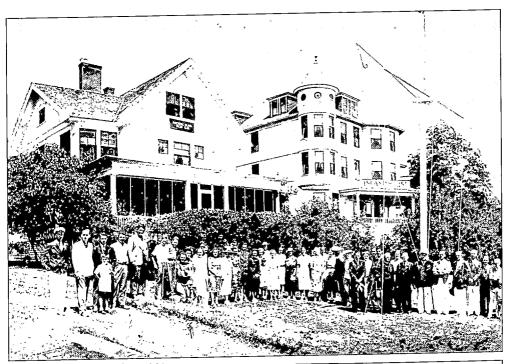

A cottage constructed in 1901 next to the Island House and across Huron Street from the harbor was donated by the Sweeney family as the Mackinac Island Yacht Club in the mid-1930s. This image, taken in the second year of the club's existence, features members and their families. The Mackinac Island Yacht Club continues to provide a seasonal base for its members' activities. (Courtesy of Mackinac Island Yacht Club.)

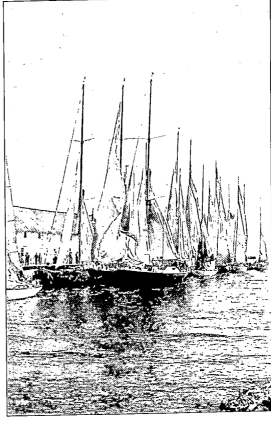

Mackinac Island has been the finish line for two prestigious, annual July sailboat races. The Chicago to Mackinac Race, which was first sailed in 1898, runs from Chicago up Lake Michigan to Mackinac—the longest freshwater event in the world. The slightly shorter Port Huron to Mackinac Race (traveling Lake Huron) commenced in 1925. This image shows race boats moored at Union Terminal Pier in an early-1900s Chicago to Mackinac Race. (Courtesy of Bentley, Poole folder 25.)

Ice Boating, Mackinac Island, Mich.

The sight of iceboats cruising across the harbor was not unusual in wintertime. The sport had a period of popularity at Mackinac Island from the 1890s to the 1920s. However, Great Lakes ice was too rough for good conditions on more than a few days each winter. Iceboats were eventually replaced by air sleds. (Courtesy of Bentley, Postcard.)

The only business located at British Landing, the Cannonball, has provided refreshments at the intersection of Lakeshore Boulevard and British Landing Road, about halfway around Mackinac Island, since 1927. Other than franchise restaurants, which have generally been avoided out of deference to the island's old-fashioned theme, there has always been a large range of independent or hotel eating establishments available seasonally. (Courtesy of Madelyn Le Page.)

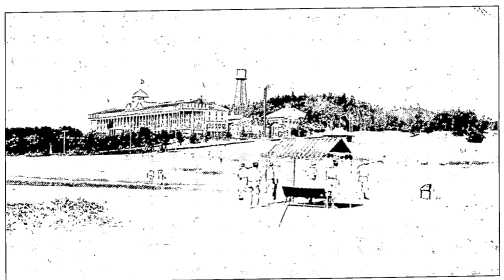

In 1917, the Grand Hotel opened its nine-hole golf course, shown here that year. Stonecliffe began another course, purchased in 1994 and finished by the Grand for its "back nine"—with carriage rides included in the greens fees. The island's Wawashkamo Golf Club is Michigan's oldest unchanged, private nine-hole course. Its original "Scottish Links" were built in 1898 to 1900, most on part of the 1814 battlefield. (Courtesy of Madelyn Le Page.)

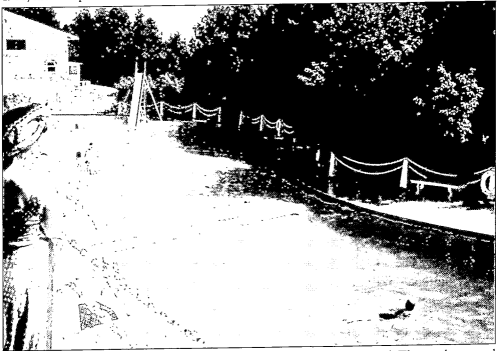

The largest swimming pool on Mackinac Island is that of the Grand Hotel. This pool was used for a swimming scene in the first major movie filmed on the island, *This Time for Keeps*, starring Esther Williams and Jimmy Durante and filmed in 1947. The second major film based on Mackinac, *Somewhere in Time*, filmed in 1979 with Christopher Reeve and Jane Seymour, has become a fantasy-romance classic. (Courtesy of Tom Pfeiffelmann collection.)

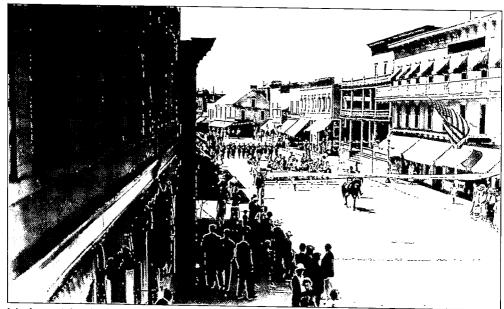

Mackinac Island has hosted a number of annual events geared toward tourists' entertainment. None is bigger than the Lilac Festival, lasting over a week in mid-June. Named after the perfume-smelling French flower that blooms prolifically and beautifully on the island, the festival has as its culmination the Grand Parade of the Lilac Festival on Huron Street, shown here in the mid-1900s. (Courtesy of Archives of Michigan and Department of Conservation.)

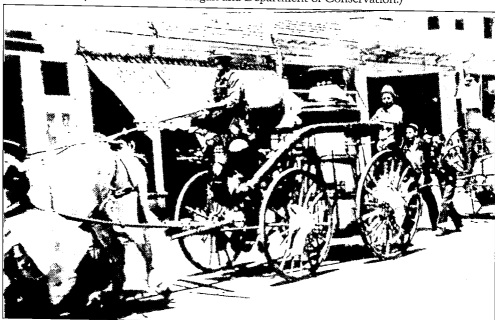

The Grand Parade of the Lilac Festival has remained a unique, non-motorized event. Since about 1980, it has been led on horseback and in traditional Native American costume by parade marshal Don "Duck" Andress, a descendant of Chief Mackinac. In between scheduled events and holidays, there has always been plenty to see and do on Mackinac Island, a premier destination for several hundred thousand visitors annually. (Courtesy of Tom Pfeiffelmann collection.)

This 1970s midsummer shot of Huron Street, with ever-present Fort Mackinac still symbolically on guard above, is not particularly historical in and of itself. But it is a visual representation showing that among the thousands of locales in the United States, Mackinac Island's history is rare, partly because so much of it can still be seen and experienced today. (Courtesy of Tom Pfeiffelmann collection.)

DISCOVER THOUSANDS OF LOCAL HISTORY BOOKS
FEATURING MILLIONS OF VINTAGE IMAGES

Arcadia Publishing, the leading local history publisher in the United States, is committed to making history accessible and meaningful through publishing books that celebrate and preserve the heritage of America's people and places.

Find more books like this at
www.arcadiapublishing.com

Search for your hometown history, your old stomping grounds, and even your favorite sports team.

Consistent with our mission to preserve history on a local level, this book was printed in South Carolina on American-made paper and manufactured entirely in the United States. Products carrying the accredited Forest Stewardship Council (FSC) label are printed on 100 percent FSC-certified paper.

MADE IN THE